F**K IVY

**and Everything Else

F**K IVY **AND EVERY-THING ELSE

MARK McNAIRY

Foreword by Nick Wooster

HARPER DESIGN

An Imprint of HarperCollins Publishers

For Nancy

FO' REAL

CONTENTS

FOREWORD

When Mark asked me to write a foreword to this book, my first thought was *Fuck off*.

Let me explain: It wasn't because I dislike Mark—I love him. "Fuck off" perfectly describes his aesthetic and his singular approach to life. In a world of political correctness and a constant stream of pabulum that permeates the current retail and publishing culture, Mark's spirit is the antidote to the neutered and the bland.

Mark's voice represents a mind-set that all generations can understand. He has co-opted "Fuck off" as a business model: he not only embodies the smart-ass and the curmudgeon; he's made a cottage industry out of the persona of the grumpy old man. But there is more to Mark than the contrarian. He gained experience at classic purveyors of taste and style, having worked with venerable institutions such as J. Press. He expertly built a career around the established, then put that experience to good use when he broke out on his own.

As a distinct and contrarian voice in ⁄menswear, Mark produces clever collections with a sense of humor and a poke in the eye, but his clothes are never trendy or trite. There's always a solid through line of East Coast establishment crossed with Travis Bickle. And he puts his money where his mouth is by stamping "Fuck off" on every leather-soled shoe. What makes Mark's vision work is that he is, at his core, classic. He understands the rules, protocol, and tradition. Then he turns it all on its ear. That, for me, is the hallmark of a genius.

INTRODUCTION

The clothing I make has heart and soul. When I design, the only limitations are the rules in my head. Sometimes, I have a hard time verbalizing those rules, and in fact, I find it excruciating when people ask me to talk about my inspiration and the creative process. So don't expect me to do it here. I would much rather be sitting at a table trying to execute my ideas, not talking about them.

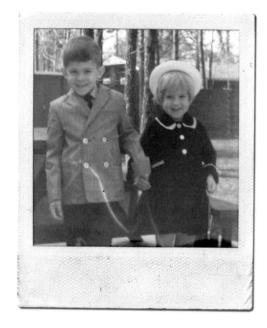

I grew up in Greensboro, North Carolina, where becoming a designer was not even a remote possibility; the opportunities just weren't there. When I moved to New York, I really had no idea what I was going to do with my life, either. I just knew that this was the place I needed to be. I began working in fashion in sales, first in North Carolina and then in New York. With respect to design, I am completely self-taught, although I really think of myself as a maker rather than a designer. I learned the process from shopping, examining details, digging around factories, and listening to people who knew a lot more than I did. And I learned that ideas can come from anywhere and that coming up with them is the easy part of the process. The execution is the ticket—and an order ain't an order until it's paid for.

My style has evolved from being afraid to express my real feelings to simply not giving a fuck. Life is too short. I like to think I make clothes for people who can think for themselves.

I have been hired to help companies revamp their brands, to help reinvent that classic, Ivy-inspired look. Well, fuck Ivy. The problem is there are too many rules, and rules are supposed to be broken. As a designer, the real turning point was during my incarceration as creative director for J. Press. Before then, I pretty much did what

I wanted, but I was always amenable to the suggestions of buyers and salespeople. At J. Press, I was hired to administer CPR to a dying brand, but the powers that be would not let me do what I was hired to do. So I said: Fuck this. I am going to do a Howard Roark, and do exactly what I want to do, and it will work, or I will go down fighting.

Thus, McNasty was born. Or born again. However you want to phrase it. And I learned to not take myself, or this business, too seriously. But the things I make are serious business to me. I've had my own company since 2009. I've always been hands-on, and I think I always will be. It is hard for me to function outside the 10018 zip code. I am in the factories almost every day, looking at fabrics and choosing buttons, zippers, and threads. This is the way I learned how to make clothes. Just like the wrong shoes can kill a whole look, the wrong button or the wrong thread can ruin a garment and send me into a shredding frenzy. I am not kidding: it has happened. I am basically designing for myself, so there are probably certain details that most people will never even notice. But I know that they are there.

I like a modern take on the traditional. Actually, I like fucking with tradition. I draw inspiration from so many places: hunting and fishing gear, military uniforms, Savile Row, Ivy League, and work wear. The inspiration can come from anywhere, even from something wadded up in the trash. The way I see it, clothing should not be so formulaic in terms of how it is made or how you wear it.

This book is an extension of my philosophy on clothing and on life: from clothes and shoes to essential knowledge, and even a few tips on being a gentleman. My suggestion: Use this book as a guide. Find your voice. Be discerning.

Or, put more simply, read (if you know how to), think (if that is possible), look at the pretty pictures, get inspired, and then go fuck yourself.

And thanks for buying the book.

—Mark McNairy
Earth, 2016

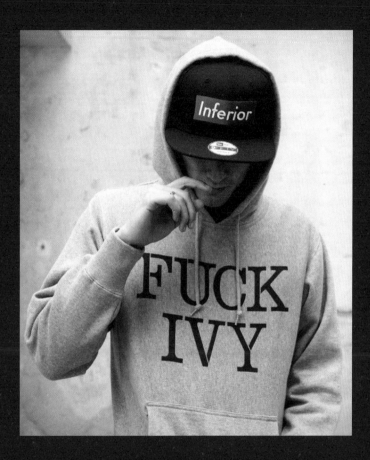

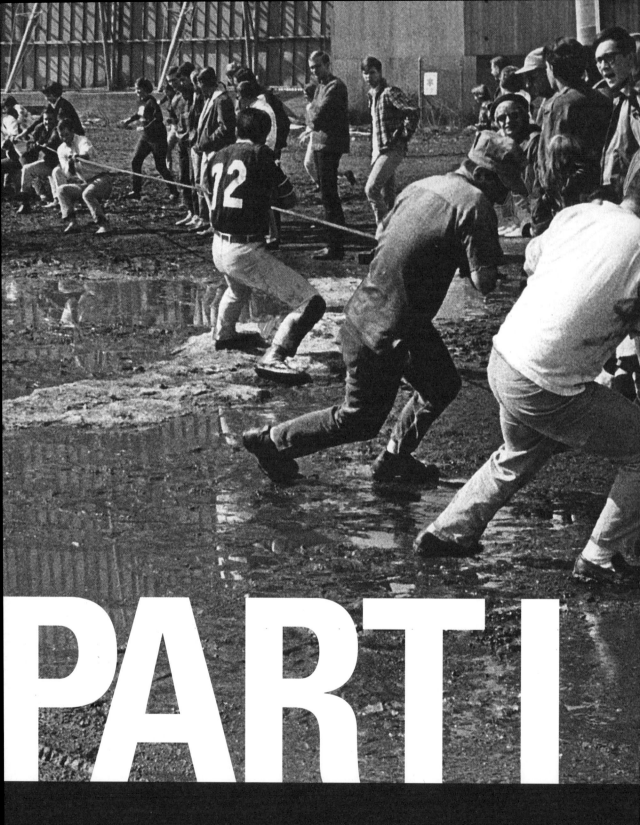

PART I

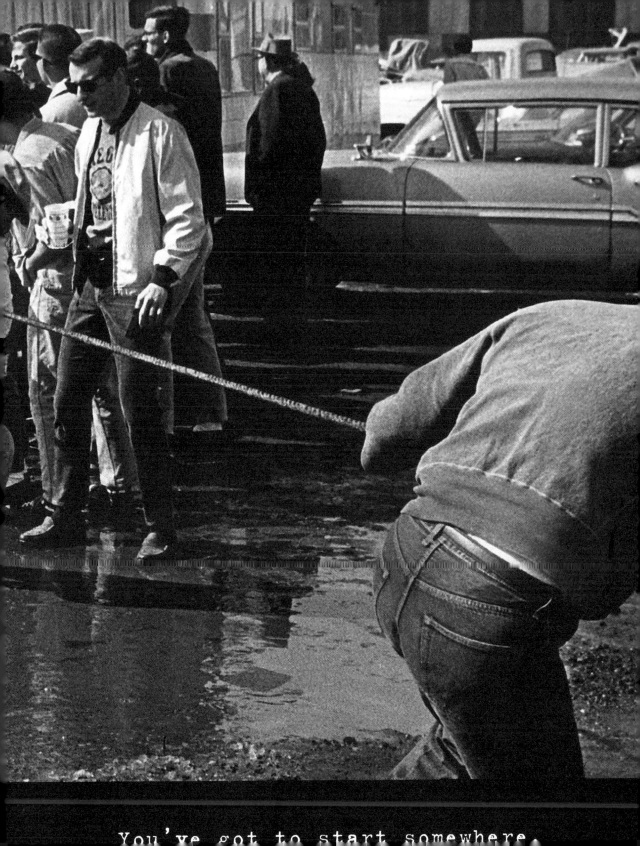

You've got to start somewhere.

THE WHITE UNDERSHIRT

SIMPLE PERFECTION.

MINIMALISM AT ITS BEST.

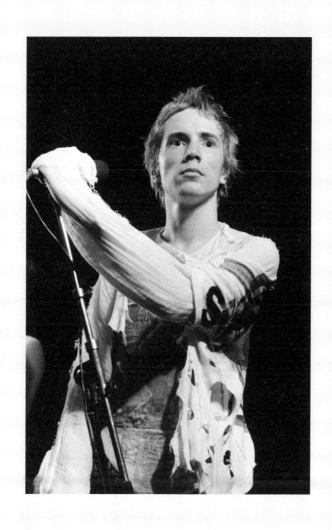

ON IMPERFECTION AND BEAUTY

Occasionally, I wear one of my favorite shirts that happens
to have a very small hole on the front of it. People like
to point out the hole to me, like I was a leper. The fact
of the matter is: I like that hole.

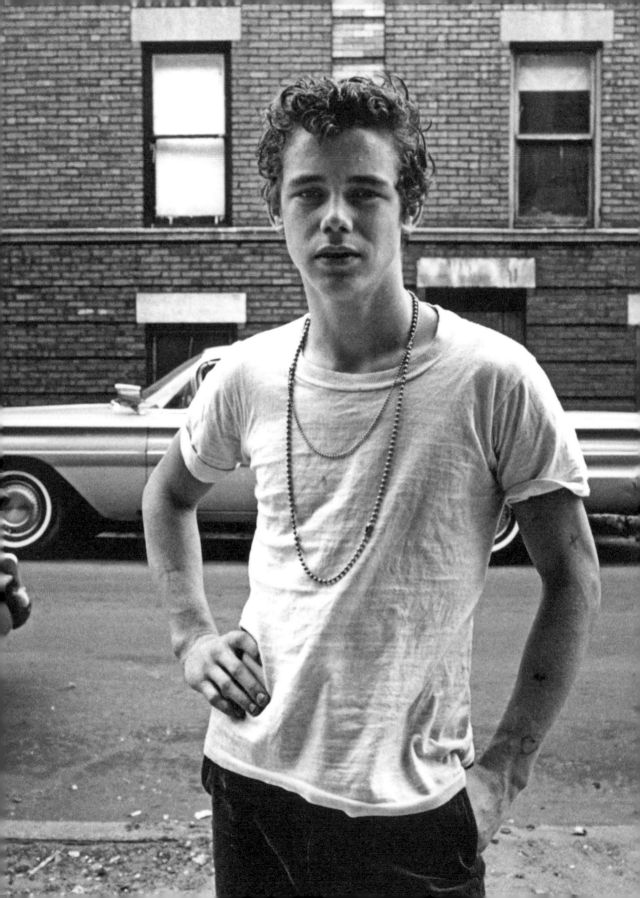

JEANS

LEVI'S... PERIOD.

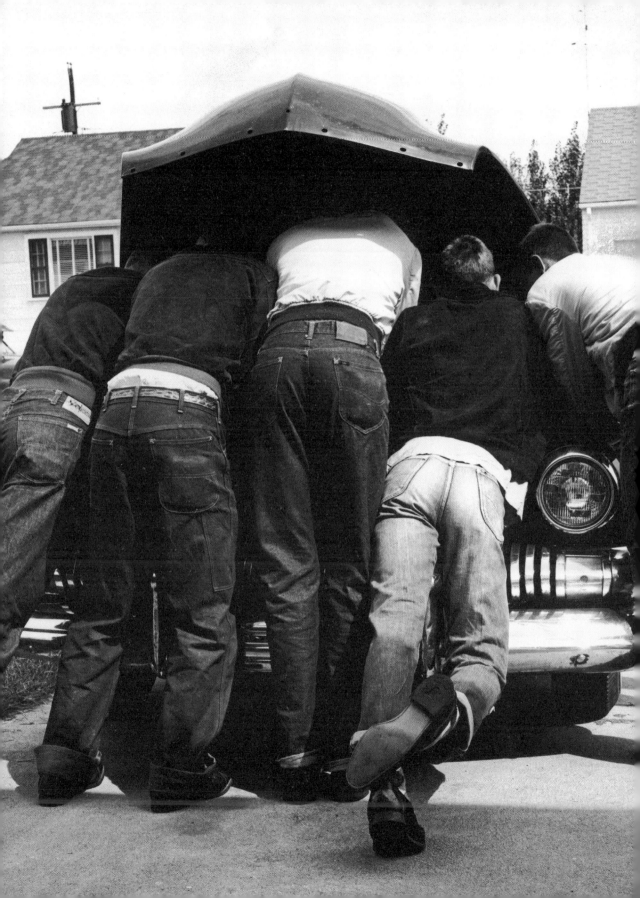

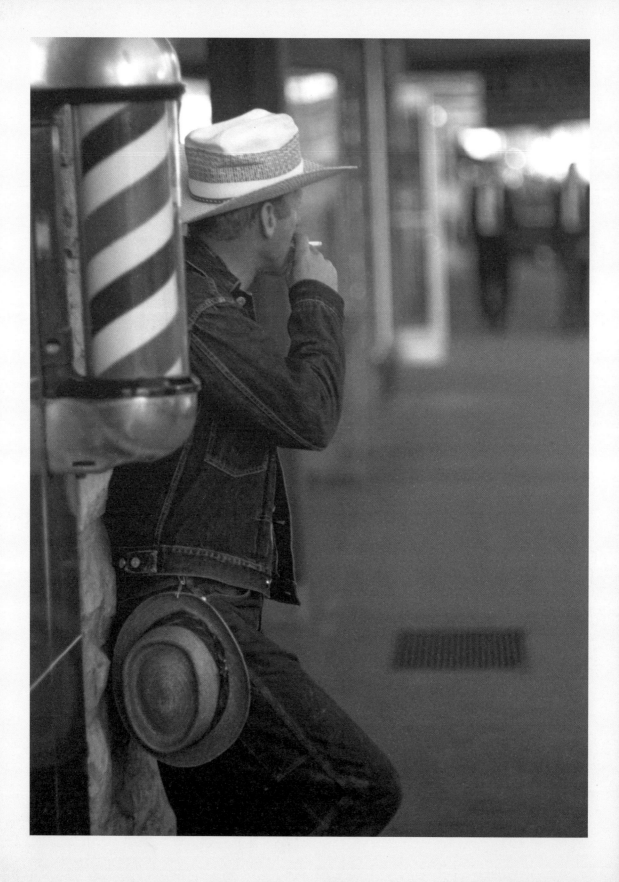

A GUIDE TO FINDING THE RIGHT DENIM BRITCHES

501: THE MACK DADDY

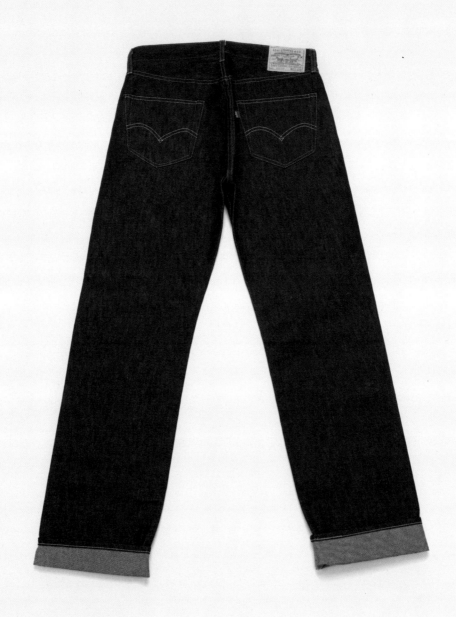

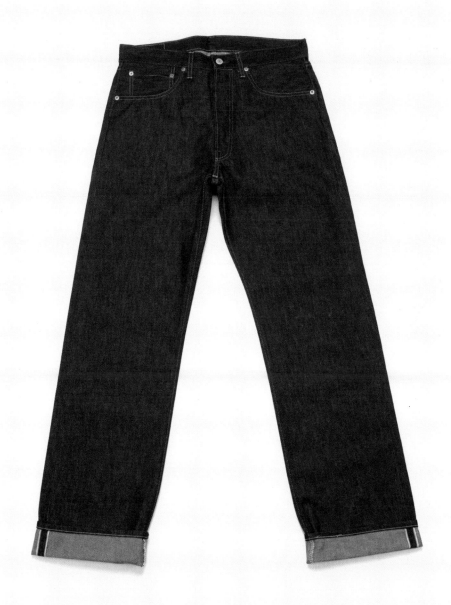

501zxx/502

IF YOU LIKE THE FIT OF THE 501 BUT DREAD THE
TASK OF REBUTTONING AFTER TAKING CARE OF
BIZNESS, GIVE THE 501ZXX OR THE 502 A SHOT.
THEY'RE BASICALLY THE SAME FIT AS THE 501 BUT
WITH A NIFTY ZIP FLY, A.K.A. QUICK RELEASE.

505-0217

THESE IS MY BITCH. THEY'RE A BIT SLIMMER IN FIT
THAN THE 501 AND BUILT WITH THAT TECHNOLOGICALLY
ADVANCED ZIP FLY.

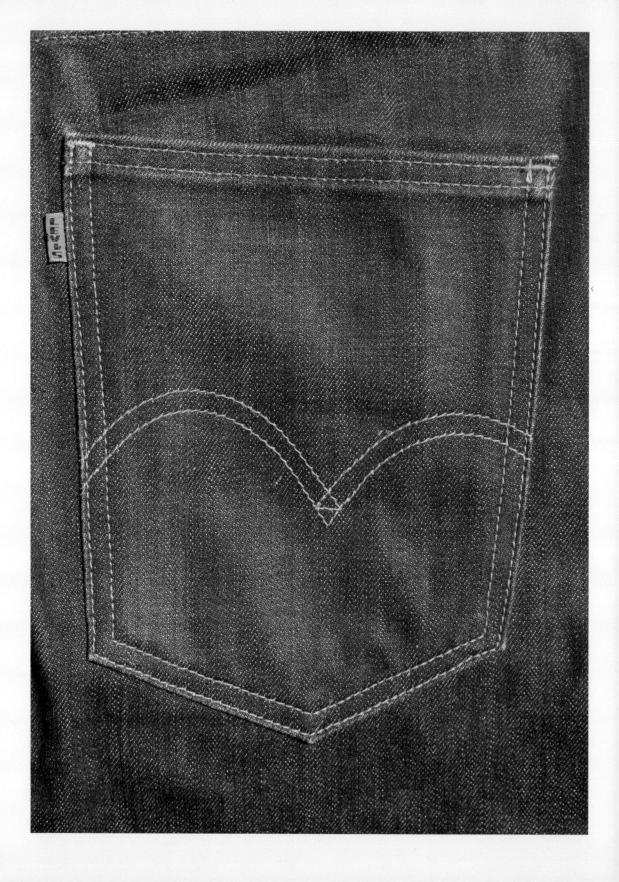

605/606

A.K.A. RAMONES JEANS OR CHICKEN SLACKS.
THE 606 WITH A LITTLE STRETCH IS PERFECT FOR
BUSTIN' A MOVE OR TWISTIN' THE NIGHT AWAY.

201: A.K.A. DROOPY DRAWERS

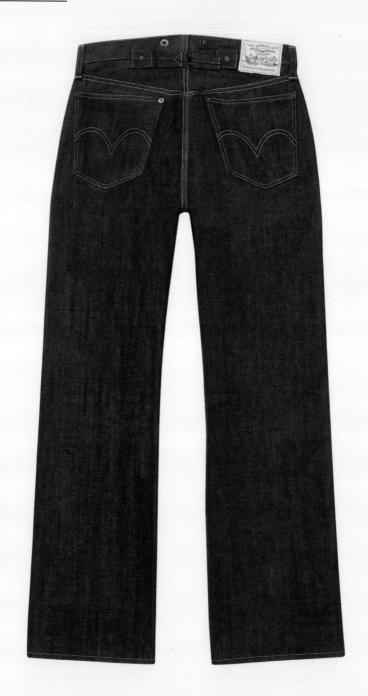

BIG AND BAGGY.

SAGGIN'

IF YOU GONNA BE SAGGIN', INVEST IN SOME NICE
UNDER-BRITCHES. SHOWIN' OFF THE HANES YOU DONE
BOUGHT AT WALMART PROBABLY ISN'T CONVEYING THE
COOL MESSAGE YOU THINK.

I SUGGEST BROOKS BROTHERS OXFORD-CLOTH BOXERS.
I USED TO WEAR THEM MYSELF, BUT THEY FELT TOO
SHORT TO ME, LIKE I WAS WEARING HOT PANTS.
SO I NOW MAKE MY OWN, WHICH ARE EXTRA LONG AND
EXTRA DOPE.

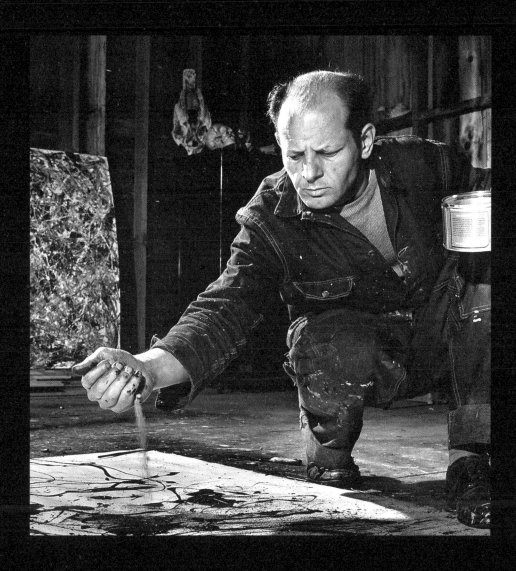

FIT

FUCK FIT.

BUY THEM A LITTLE BIG AND WEAR A BELT TO HOLD THEM UP.

AND FOR GOD'S SAKE, PLEASE DO NOT BE A WOMAN AND HEM YOUR
JEANS. BE A MAN: ROLL 'EM UP AND GET ON WITH YOUR BUSY DAY.

HOW TO CARE FOR JEANS

DO NOT WASH THEM. DIRT IS LIKE COOL.

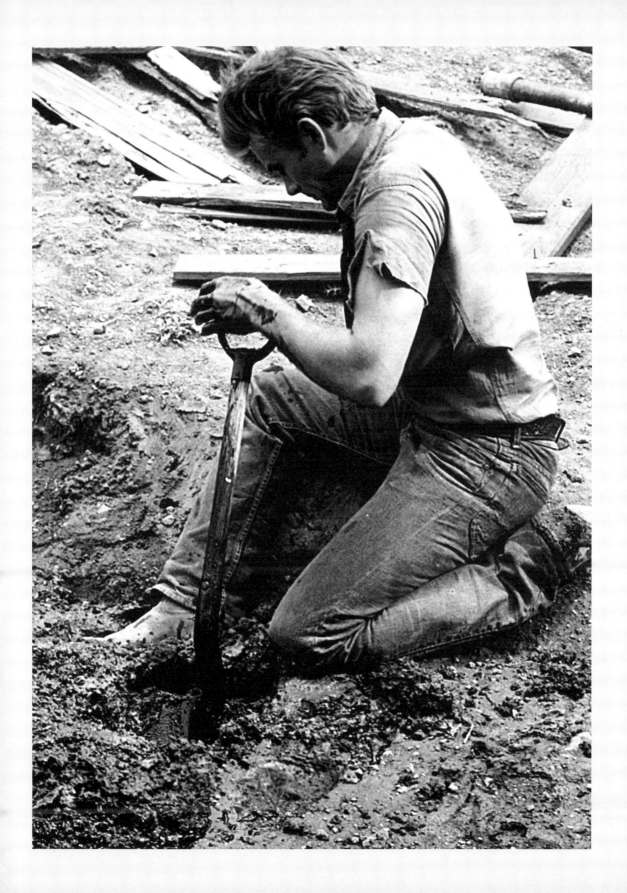

KHAKI TROUSERS—

AND NOT JUST ANY PAIR, EITHER.

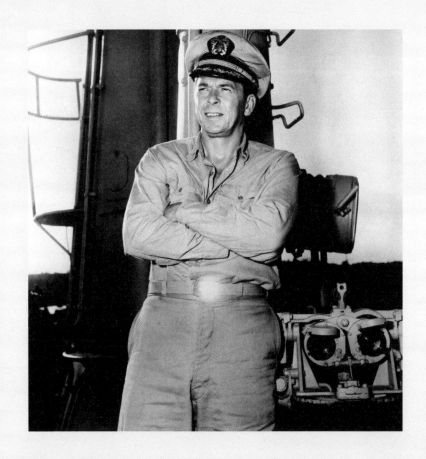

I HAVE AMASSED ABOUT A MILLION PAIRS OF VINTAGE U.S. MILITARY KHAKI
TROUSERS, BUT THE BEST ARE THE REAL McCOY'S, WHICH ARE BETTER THAN
THE REAL McCOY. THIS JAPANESE BRAND GOES TO EXCRUCIATING LENGTHS TO
REPLICATE EVERY DETAIL.

YOU CAN THANK SIR HENRY LAWRENCE.

LAWRENCE WAS A BRITISH MILITARY OFFICER STATIONED IN INDIA IN THE 1840s AND A GUY WHO SHARED MY STRONG BELIEF IN PERSONAL COMFORT. BECAUSE OF THE EXTREME HEAT, HE TOOK TO WEARING HIS LIGHTWEIGHT PAJAMA BOTTOMS ON DUTY, CAKING THEM WITH DIRT (*KHAKI* MEANS "SOIL COLOR" IN URDU) TO MAKE THEM LOOK LIKE HIS UNIFORM. HIS BUDDIES FOLLOWED HIS EXAMPLE, AND EVENTUALLY ARMIES AROUND THE GLOBE DID TOO.

Chinos are a derivative of khakis. The pants were modeled after British military uniforms, but because there was a need to conserve fabric, chinos had flat fronts and few, if any, pockets.

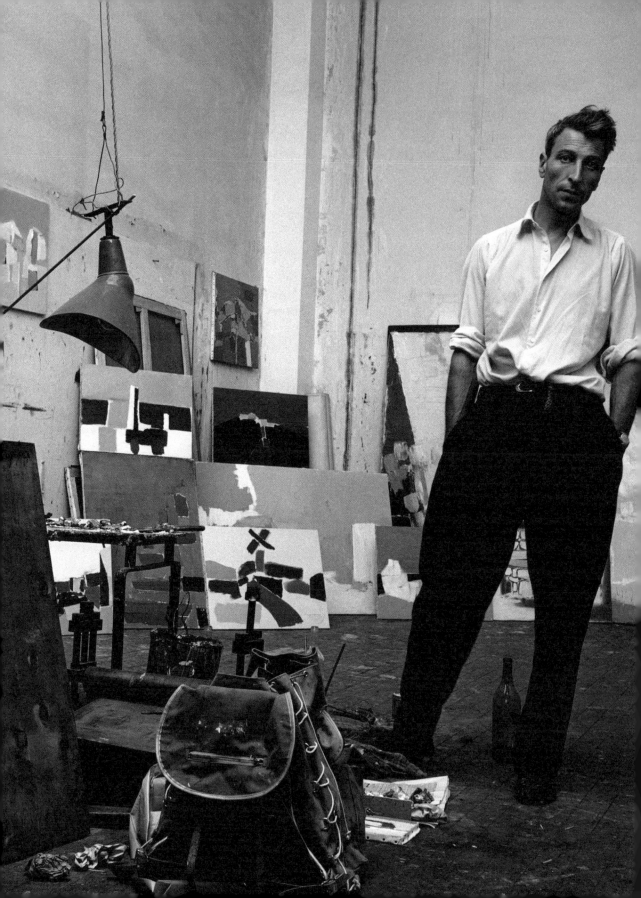

WORSTED-WOOL CHARCOAL TROUSERS

YOU NEED TWO PAIRS: TROPICAL WEIGHT FOR THE WARM MONTHS
AND FLANNELS TO CUT THE CHILL IN WINTER.

PAIR THEM WITH A WHITE SHIRT, A BROWN ALLIGATOR BELT,
A PAIR OF McNAIRY BRITISH TAN WHOLECUT DERBY SHOES,
AND WATCH OUT. . . . YOU BALLIN'.

THE OXFORD-CLOTH BUTTON-DOWN

EVERY GUY NEEDS A WHITE OXFORD-CLOTH BUTTON-DOWN COLLAR SHIRT AS WELL AS A BLUE ONE AND A NICE NAVY-AND-WHITE BENGAL STRIPE.

"Button-down" refers to the collar; all shirts button down the front. If a shirt doesn't button all the way down, it is called a *pop over*, and if it's made with a knit, it is a polo. Otherwise, it is simply a shirt.

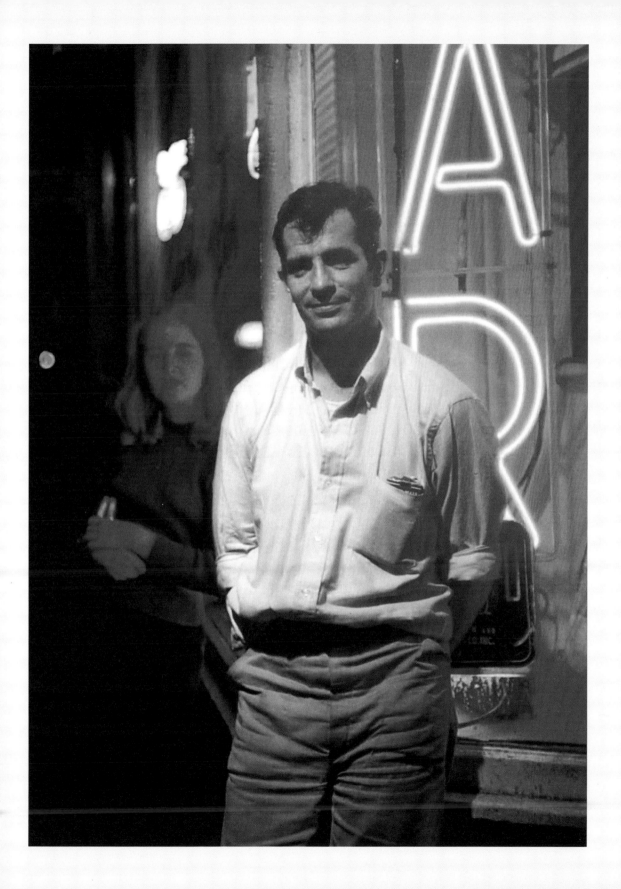

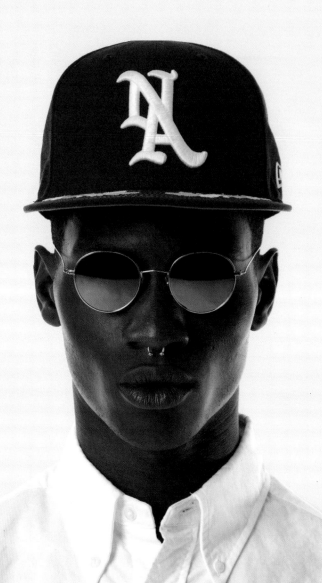

MONO-GRAMMING

WHY?

DON'T YOU KNOW IF THE SHIRT BELONGS TO YOU? DO YOU NEED TO
CONVEY THAT YOU ARE NOT WEARING A BORROWED SHIRT? DO YOU FORGET
WHO YOU ARE FROM TIME TO TIME?

IF YOU ARE GOING TO HAVE SOMETHING EMBROIDERED ON YOUR SHIRT,
AT LEAST TRY SOMETHING FUNNY, INTERESTING, EDUCATIONAL OR
MILDLY ENTERTAINING.

(Do I need an Oxford comma after "educational"?)

THE NAVY BLAZER

UNLESS YOU IS IN NICKELBACK, CREED, OR SOME OTHER SUPERCOOL
ROCK 'N' ROLL BAND, YOU PROBABLY NEED ONE OF THESE.

ASKING WHY THE NAVY BLAZER IS SO IMPORTANT IS LIKE ASKING THE
MEANING OF LIFE. I HAVE NO IDEA, BUT TRUST ME ON THIS ONE. THE NAVY
BLAZER IS A BIT MORE APPROPRIATE FOR THE BIZNESS WORLD: A NAVY
BLAZER AND CHARCOAL-GRAY SLACKS ARE A LITTLE LESS FORMAL THAN A REAL
SUIT. I USUALLY WEAR MY NAVY BLAZER WITH A SHIRT UNDERNEATH.

NEVER WEAR A NAVY BLAZER WITH KHAKI TROUSERS—A HORRIBLE COMBINATION
THAT WAS ESTABLISHED AFTER WORLD WAR II.

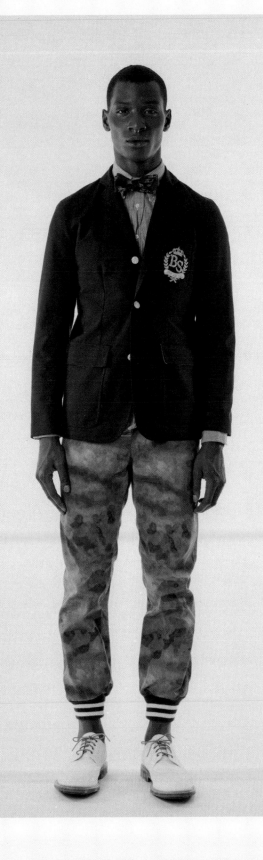

"YOU SAY YOUR JACKET IS
CONSTRUCTED WITH A HAND-BASTED
FULL-CANVAS FRONT?

...REALLY?"

WHO GIVES A FUCK? NOBODY.

SOME OF MY FAVORITE ARTICLES OF CLOTHING HAPPEN TO BE POORLY CONSTRUCTED
PIECES OF SHIT. ACTUALLY, I PREFER IRREGULAR CLOTHING TO FIRST QUALITY.
THAT IMPERFECTION MAKES THE PIECE MINE AND MINE ALONE.

HOOK
VENTS

VS.

SIDE
VENTS

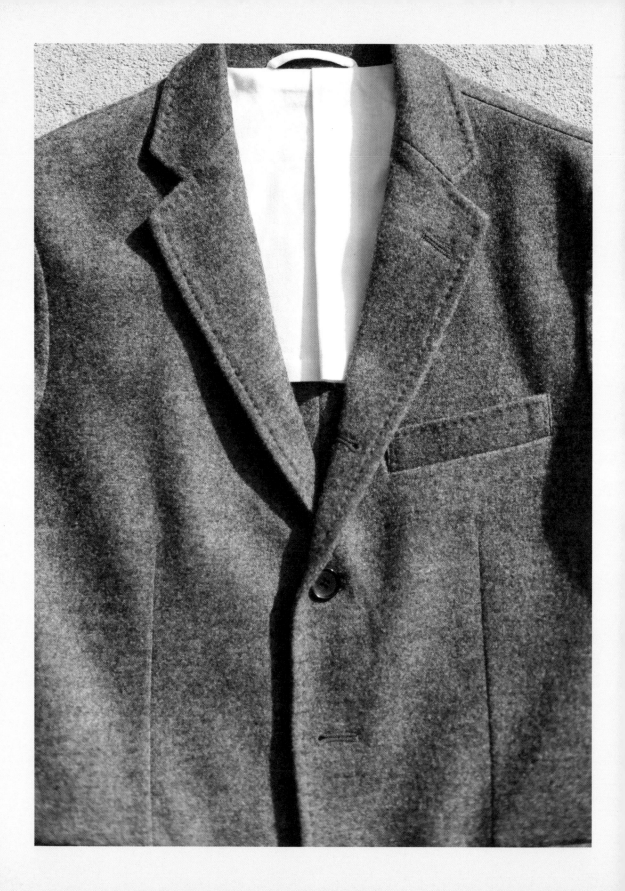

DO NOT EVER BUTTON THE TOP BUTTON OF THIS JACKET.

AND NEVER, NEVER, NEVER BUTTON THE BOTTOM BUTTON ON ANY JACKET. UNLESS, OF COURSE, IT IS A ONE-BUTTON JACKET.

A THREE-PIECE CHARCOAL SUIT

FRANCIS FUCKING SINATRA.

AIN'T NOTHING LIKE THE FEELING OF A PROPER-FITTING SUIT.

- —A THREE-PIECE CHARCOAL SUIT ALWAYS LOOKS DAPPER WITH A PAIR OF CHOCOLATE-BROWN, SUEDE, ENGLISH-MADE SHOES.

- —YOU CAN WEAR THE SUIT TO WORK, TO DINNER, TO A WEDDING OR A FUNERAL OR ANY TYPE OF CEREMONY, TO COURT, TO THE GAS STATION, ON STAGE, BACKSTAGE, OR TO BED IF YOU ARE WASTED, BUT I WOULD NOT SUGGEST WEARING IT IF YOU ARE MOWING THE GRASS OR WORKING ON YOUR CAR'S TRANSMISSION.

- —YOU DON'T HAVE TO WEAR THE VEST WITH THE SUIT.

- —YOU CAN WEAR IT WITH A PAIR OF JEANS, BUT PLEASE DO NOT DO A BONO AND FORGET TO PUT A SHIRT UNDERNEATH.

- —YOU CAN WEAR THE TROUSERS WITH A JEAN JACKET. AND YOU CAN WEAR THE SUIT JACKET WITH JEANS.

HOW DO I WEAR MY THREE-PIECE CHARCOAL SUIT?

LET ME COUNTETH THE WAYS:

- —ALWAYS WITH A SHIRT.

- —SOMETIMES WITH A TIE OR BOW TIE.

- —USUALLY WITH SHOES, UNLESS I HAD A LITTLE TOO MUCH TO DRINK.

- —USUALLY WITH CLEAN UNDERBRITCHES, IF I CAN FIND A PAIR.

- —SOMETIMES WITH AN AMERICAN-ALLIGATOR BELT.

- —ALWAYS WITH A WAD OF CASH IN THE POCKET.

- —NEVER WITHOUT A POCKET SQUARE OR A PARKER JOTTER IN THE BREAST POCKET.

- —SOMETIMES WITHOUT THE VEST.

- —SOMETIMES WITHOUT THE PANTS—THAT IS, WITH A PAIR OF THE AFOREMENTIONED JEANS INSTEAD.

ALWAYS CARRY YOUR OWN PEN.

AND I DON'T MEAN A CHEWED-UP BIC STICK WITH THE CAP
MISSING OR THE RITZ-CARLTON PEN YOU FOUND ON YOUR
BUDDY'S COFFEE TABLE.

A CLASSIC PARKER JOTTER IS MY PEN OF CHOICE. IT IS
GOOD-LOOKING AND PERFORMS LIKE A CHAMP. IT IS ALSO
VERY AFFORDABLE, SO YOU DO NOT HAVE TO CRY IF SOMEONE
BORROWS IT AND FORGETS TO RETURN IT TO YOU.

IT IS ALWAYS NICE TO BE ABLE TO HELP OUT WHEN YOUR
FELLOW MAN NEEDS A PEN.

THINK ABOUT IT: DO YOU REALLY WANT TO USE THE PEN THAT
THE WAITER BRINGS WITH THE CHECK? THE SAME PEN HE DROPPED
ON THE FLOOR BY THE URINAL? THE SAME PEN THAT SOME GUY
WHO ALWAYS HAPPENS TO HAVE HIS HAND DOWN HIS TROUSERS
JUST USED TO SIGN THE CHECK BEFORE YOU?

CASH

A MAN SHOULD, AT ALL TIMES, HAVE CASH IN HIS POCKET.

WHEN YOU SAY YOU NEED TO GO TO THE ATM, EVERYONE
PRETTY MUCH ASSUMES THAT YOU AIN'T GOT NONE.

MONEY CANNOT BUY HAPPINESS.

BUT LACK OF IT SURE CAN CAUSE MISERY.

AND MONEY CANNOT BUY LOVE.

BUT THERE AIN'T NO ROMANCE WITHOUT FINANCE.

THE ONLY TIES YOU WILL EVER NEED

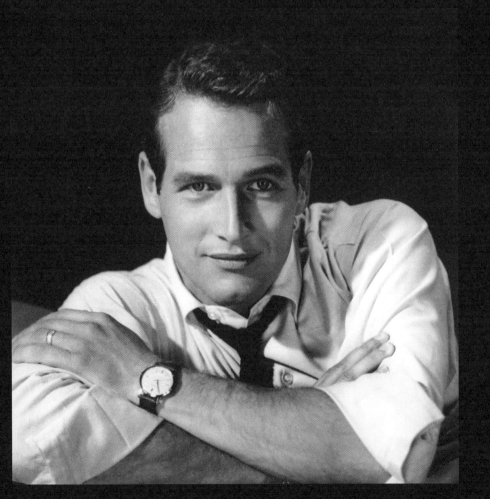

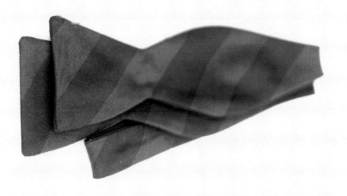

A NAVY AND WINE REGIMENTAL

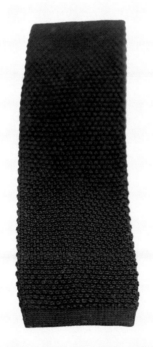

A BLACK SILK KNIT

THE REGIMENTAL TIE WAS ORIGINALLY A WAY FOR THE WEARER TO DISPLAY
AN AFFILIATION WITH A CLUB, SCHOOL, ORGANIZATION, OR ASSOCIATION.
SOME OF THE SHOPS ON SAVILE ROW AND JERMYN STREET WILL NOT DISPLAY
THE REGIMENTAL TIE SO AS TO SPARE UNEDUCATED, FOOLISH TOURISTS THE
EMBARRASSMENT OF ATTEMPTING TO PURCHASE A TIE FOR WHICH THEY DON'T
HAVE AN AFFILIATION.

THE TIE BAR

HOW COULD SOMETHING SO SMALL BRING SO MUCH
HAPPINESS? SIMPLE THINGS PLEASE SIMPLE MINDS.
FASTEN IT TO YOUR SHIRT AND NECKTIE SO THAT
THE TIE DOES NOT FLY UP AND HIT YOU IN THE
FACE WHEN YOU ARE JUMPING FOR JOY OR RIDING
YOUR POGO STICK.

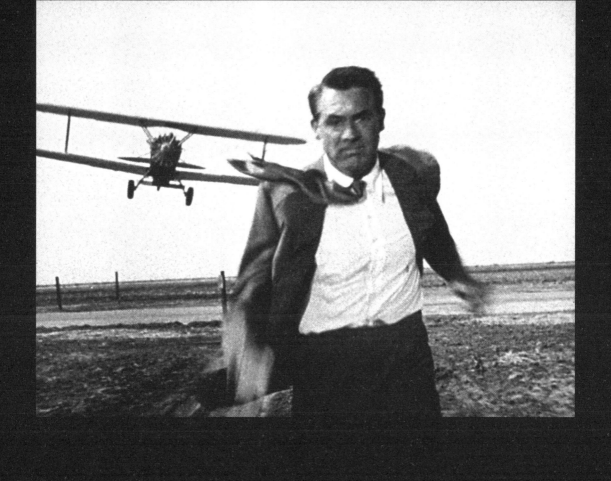

THE BOW TIE

FOR GOD'S SAKE . . .

WHETHER OR NOT YOU WEAR EITHER ON A REGULAR BASIS,
PLEASE LEARN HOW TO TIE A TIE AND A BOW TIE.

I ASSURE YOU THESE SKILLS WILL COME IN HANDY ONE DAY.

A TUXEDO

INVEST IN A TUXEDO.

- -THE JACKET AND THE TROUSERS ARE THE ONLY REALLY IMPORTANT PARTS—FORGET THE REST.
- -WEAR IT WITH A WHITE OXFORD-CLOTH BUTTON-DOWN SHIRT.
- -ANY SOLID-BLACK TIE WILL DO—EITHER A NECKTIE OR A BOW TIE.
- -CUMMERBUNDS ARE STUPID.
- -A VEST WITH A TUX IS USELESS CLUTTER.
- -IF THE PANT HAS AN EXTENSION WAISTBAND, THEN YOU DON'T NEED A BELT. BUT IF YOU WEAR ONE, THEN GO FOR ONE IN A NICE BLACK AMERICAN ALLIGATOR.
- -FUCK THE RULES: THOSE BLACK-PATENT PUMPS MAKE YOU LOOK LIKE A REAL DOUCHE BAG. WEAR THE CHURCH'S SHANNON BLACK BINDER OR A PAIR OF CHUCK TAYLOR 1970S. AND SHOW SOME ANKLE WHILE YOU ARE AT IT.

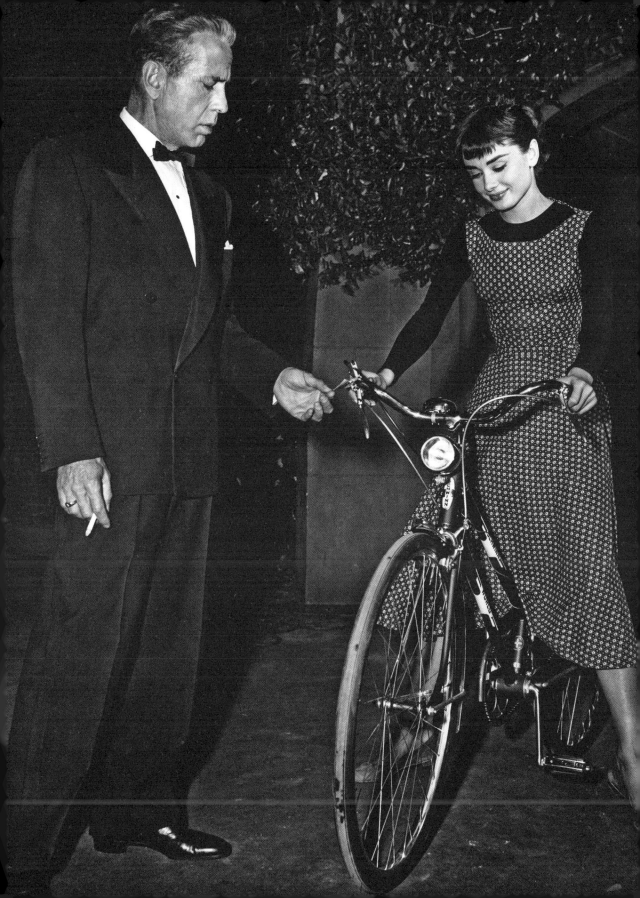

SHOES MAKETH THE MAN.

IT'S LIKE JUDGING A BOOK BY ITS COVER.

WHILE JESUS MAY NOT APPROVE, LOOKING AT SOMEONE'S
SHOES IS A VERY EFFECTIVE MEANS OF SIZING HIM UP.

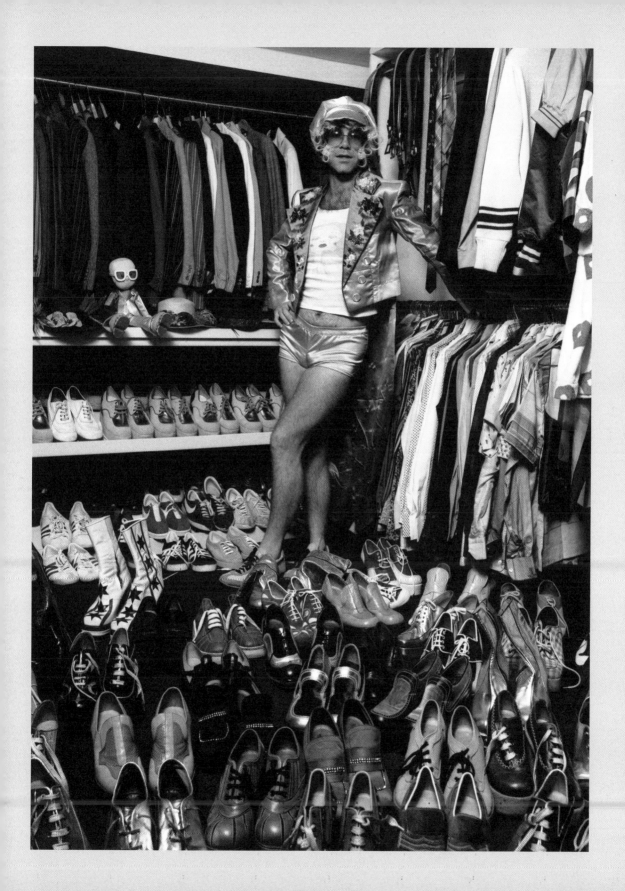

REMEMBER, YOU ARE NOW A BIG BOY...

SO PLEASE ACT ACCORDINGLY. YOU CHOOSE WHICH GOLF CLUBS TO BUY, CAN TELL US HOW THEY ARE MANUFACTURED, AND RECITE THE MATERIALS FROM WHICH THEY ARE MADE, SO PICK OUT YOUR OWN SHOES AND TRY TO LEARN A LITTLE BIT ABOUT THEM. DO NOT LET YOUR WIFE OR GIRLFRIEND DO YOUR SHOE SHOPPING FOR YOU.

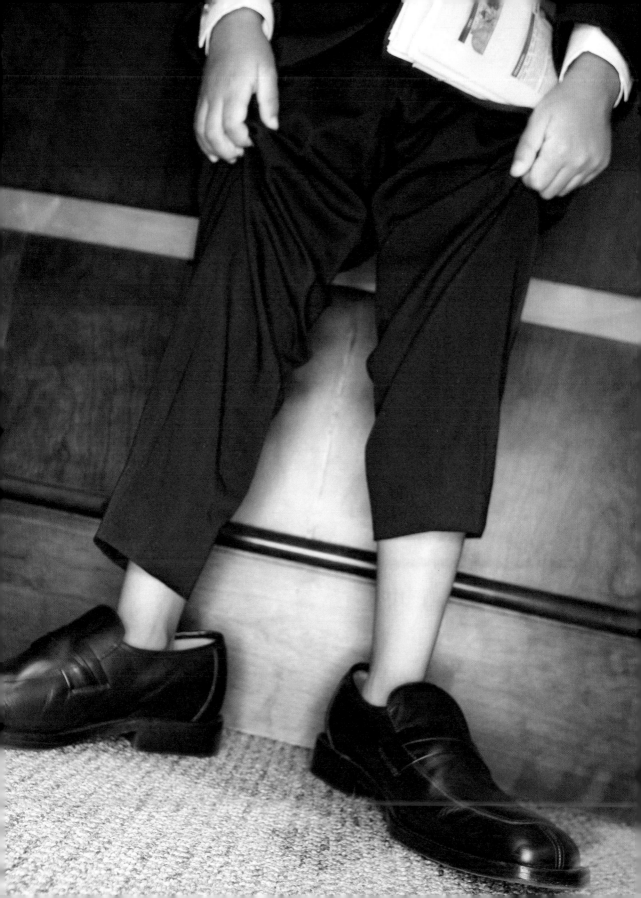

BROWN BROGUES

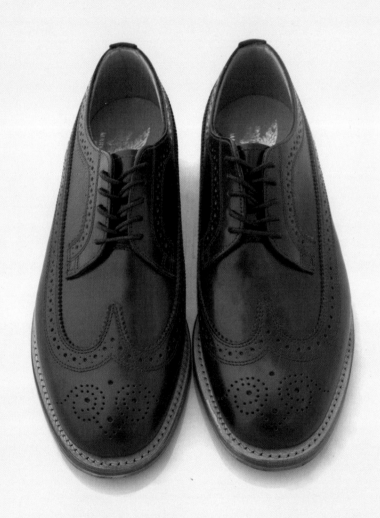

THE FIRST PAIR OF PROPER SHOES YOU SHOULD BUY. YOU
CAN WEAR THEM WITH A SUIT, GRAY FLANNEL TROUSERS,
JEANS, KHAKI SHORTS, JUST ABOUT EVERYTHING.

CHURCH'S SHANNON
BLACK POLISHED BINDER

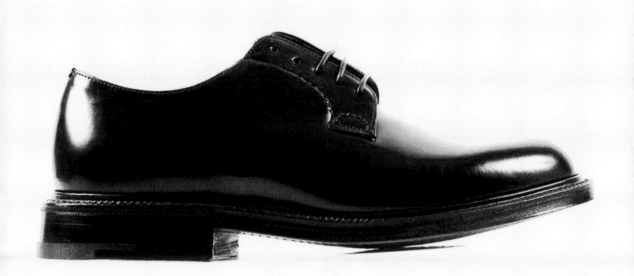

A MASTERPIECE.

A CLEAN AND CLASSIC WHOLECUT DERBY PIECE OF
BEAUTY MADE OF A SINGLE PIECE OF LEATHER AND
WITH A THICK TRIPLE SOLE.

I HAVE TRIED REPEATEDLY TO REPLICATE IT TO NO
AVAIL AND HAVE THUS GIVEN UP.

JUST LOOK AT HER.

FYI . . .
THIS
SOLE
IS MADE
OF
LEATHER,
NOT
WOOD.

CLOGS HAVE WOODEN SOLES. NOT BROGUES.

HOWEVER, SOME OF MY CREATIONS ARE SO FUCKIN'
AWESOME THAT THEY HAVE BEEN KNOWN TO CAUSE WOOD.

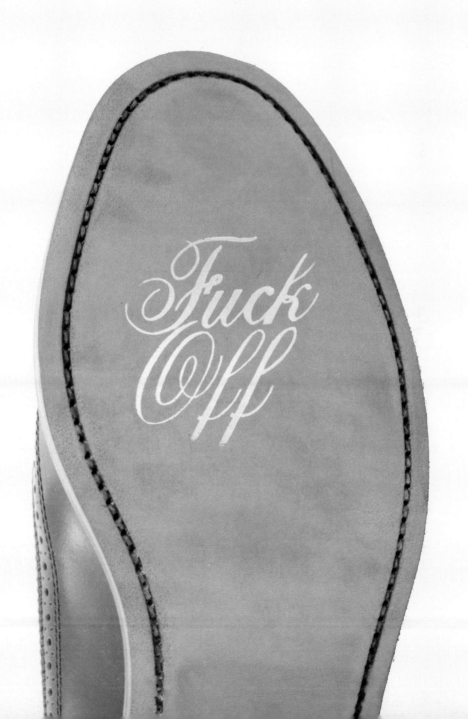

WHITE BUCKS

WEAR WHITE BUCKS AT ANY TIME OF THE YEAR THAT
YOU CHOOSE TO DO SO. AFTER ALL, IT SEEMS TO
BE JUST FINE FOR EVERYONE ELSE TO WEAR WHITE
NEW BALANCE SHOES ANY TIME THEY LIKE, SO WEAR
WHITE BUCKS ON A NICE SUNNY DAY IN OCTOBER,
NO MATTER WHICH HEMISPHERE YOU'RE IN.

FUCK LABOR DAY.

AND FUCK YOU TOO.

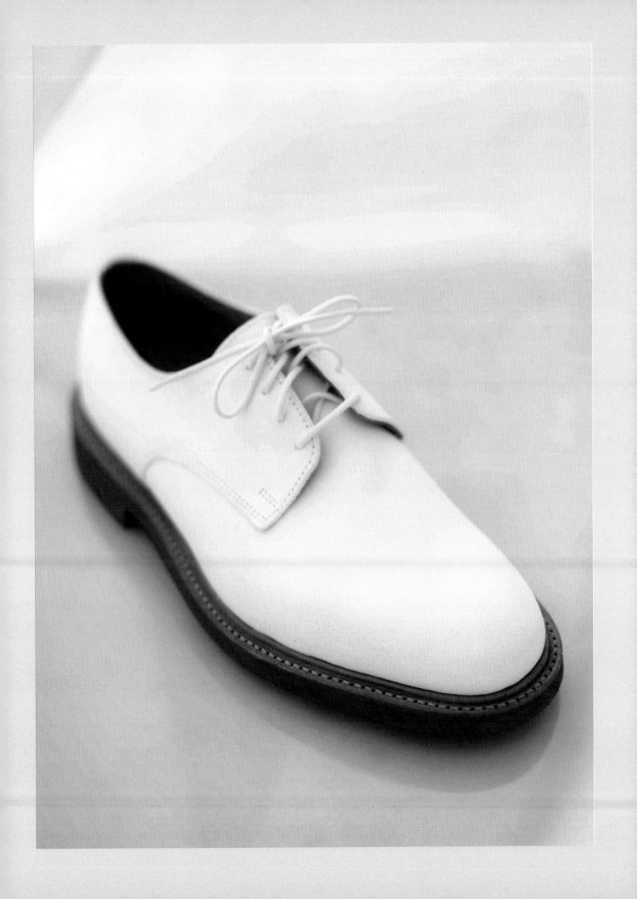

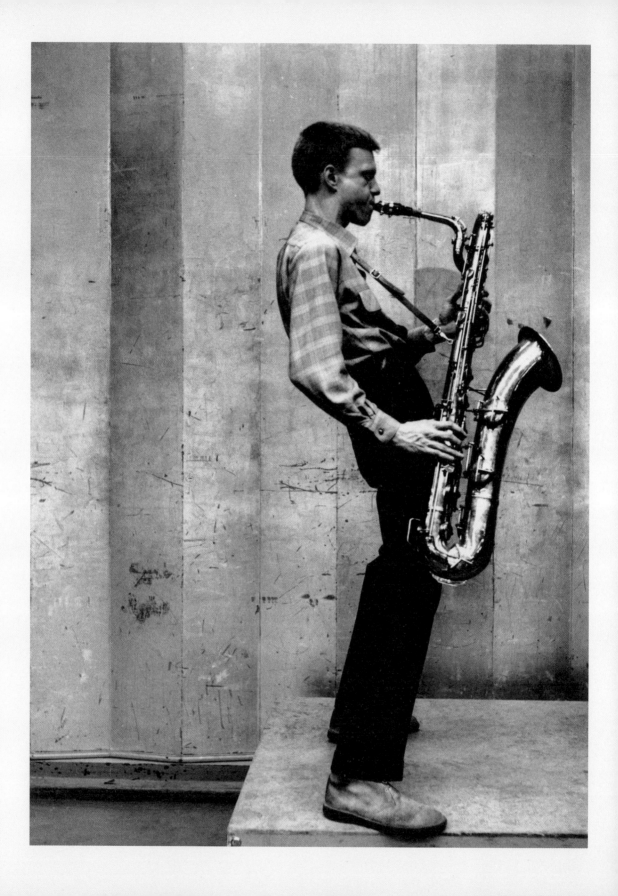

DESERT BOOTS

WHETHER YOU'RE BLOWIN' A HORN, BLOWIN' OFF
STEAM, BLOWIN' HOT AIR, OR BLOWIN' A DUDE . . .

IT'S HARD TO GO WRONG WITH THESE.

DESERT BOOTS ARE SIMPLE PERFECTION.

ASK ANDY SPADE. I DO NOT THINK I HAVE EVER
SEEN THAT GUY WEAR ANY OTHER SHOE.

DO NOT MESS WITH PERFECTION.

OWN A ZIPPO LIGHTER, WHETHER YOU SMOKE OR NOT.

YOU NEVER KNOW WHEN YOU MIGHT NEED TO BURN A BRIDGE.

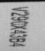

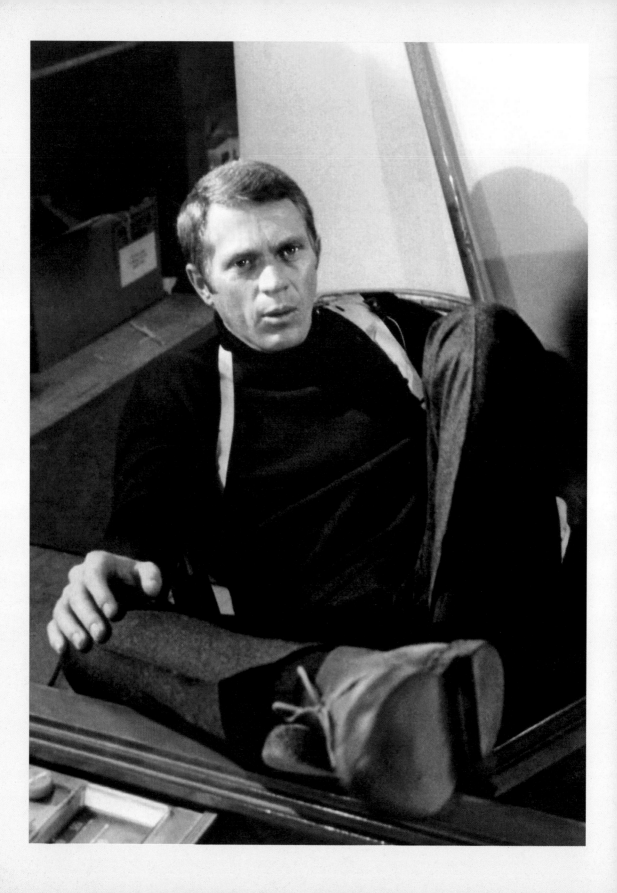

THE
PLAYBOY

RESERVED FOR THE COOLEST OF THE COOL.

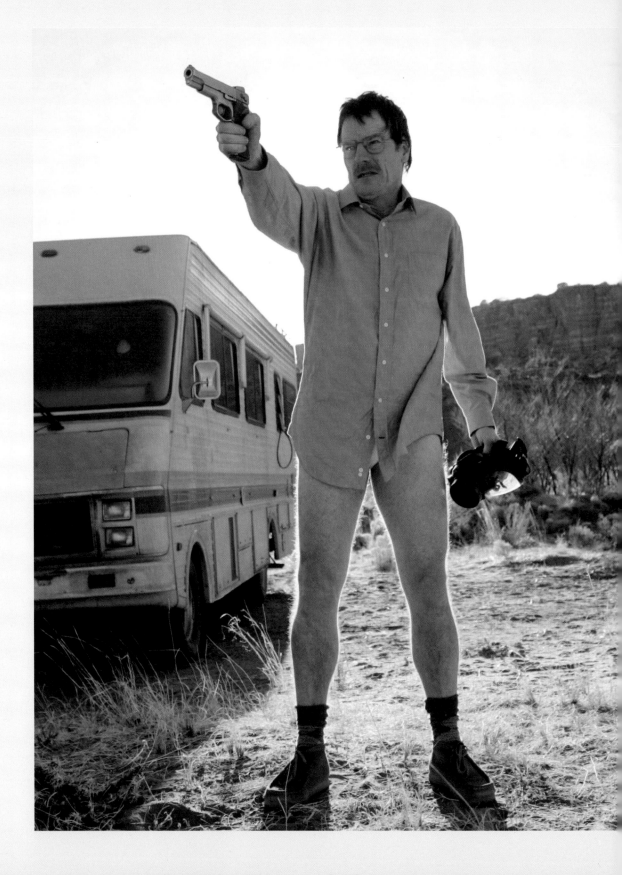

HAPPY SOCKS MAKE ME ANGRY.

AND THEY MAKE YOU LOOK LIKE A DICK.

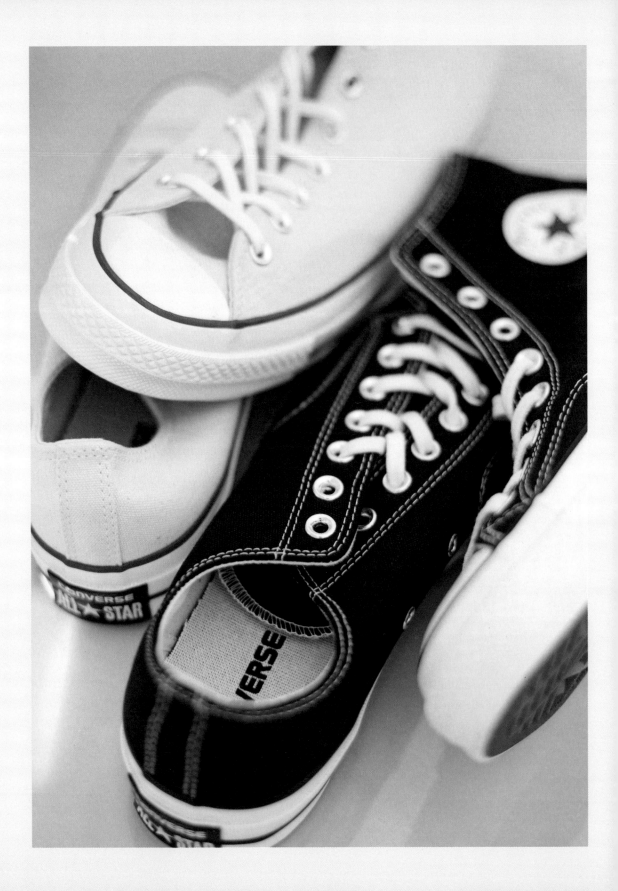

HELLO, CHARLES.

WHEN THEY CAME OUT WITH THESE REPLICAS OF CHUCK
TAYLOR 1970S, I THOUGHT I HAD DIED AND GONE TO
HEAVEN. THEY ARE BASICALLY AN EXACT REPRODUCTION
OF THE SHOE MADE IN THE UNITED STATES THAT I
WORE GROWING UP.

WEAR THEM WHENEVER YOU FEEL LIKE IT. THEY ADD
SWAG TO A SUIT OR EVEN TO A TUXEDO. AND THEY
CONVEY THE MESSAGE THAT YOU INDEED DOES GOTS
IT GOIN' ON.

BUT IF YOU HAPPEN TO BE WEARING THOSE CONVERSE
WITH THE MISSING LACES, YOU ARE TOO FAR GONE.
DON'T WORRY ABOUT IT. IN FACT, PUT THIS BOOK DOWN
RIGHT NOW AND PLEASE GET THE FUCK OUT OF HERE.

TWISTED SHOELACES

OR TWISTED SISTER.

I AM NOT SURE WHICH I FIND MORE UNAPPEALING.

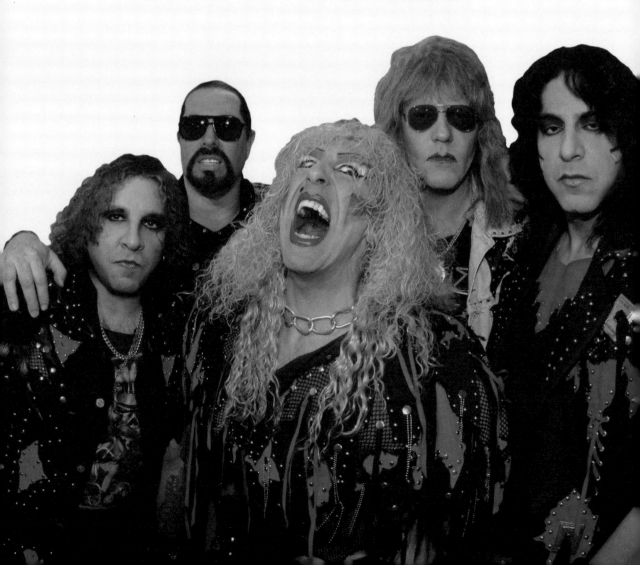

FLIP-FLOPS

NO.

WHY DO YOU HAVE TO WEAR FLIP-FLOPS ON AN AIRPLANE? I AM
ALL FOR RELAXING THE SPORTS JACKET/RESTAURANT RULE,
BUT WHEN I AM DINING, DO YOU THINK THAT I OR ANYONE ELSE
REALLY WANTS TO SEE YOUR FILTHY, FUNGUS-INFECTED DIGITS?

AND I GUESS WITH GLOBAL WARMING AND SHIT, I CAN DEAL
WITH A TANK TOP, BUT WHY DO YOU WEAR FLIP-FLOPS WALKING
THE STREETS OF NEW YORK CITY? DO YOU THINK YOUR TOES
ARE PRETTY? I COULD BE MISTAKEN, BUT I PERSONALLY HAVE
NEVER HEARD OF A WOMAN WITH A FOOT FETISH.

YOUR CAP DOES NOT HAVE TO MATCH YOUR SNEAKERS.

THIS PHOTO REMINDS ME OF MY MOM, WHO USED TO
TAKE HER SHOES TO THE DEPARTMENT STORE TO TRY
AND FIND A SWEATER THAT MATCHED THEM.

LEATHER BELTS

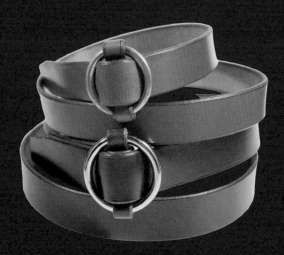

DURING MY TIME AT J. PRESS, I WAS TRYING TO REPLICATE THE SMART,
CASUAL CINCH BELT FROM THE COMPANY'S EARLY 1960S CATALOGS. LO AND
BEHOLD, ONE DAY WHILE VISITING MY FRIEND AND HERO, GEORGE GRAHAM,
I HAPPENED TO FIND IT IN HIS SHOWROOM. THESE BELTS, MADE BY WILEY
BROTHERS IN CHARLOTTESVILLE, VIRGINIA, ARE THE BEE'S KNEES. I OWN
THREE: BLACK, BROWN, AND TAN. I WEAR THEM WITH JEANS, A SUIT, AND
EVERYTHING IN BETWEEN.

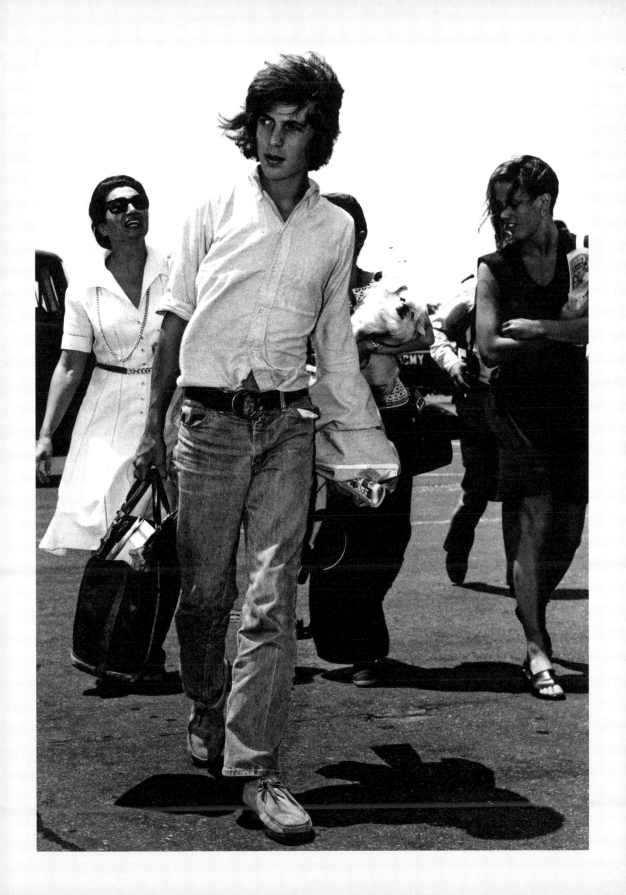

RIBBON BELTS

WHILE YOU'RE AT IT, YOU MIGHT AS WELL PICK UP ONE
OF THESE. THEY'RE NICE TO HAVE—AND THEY'RE CHEAP.

ALLIGATOR BELTS

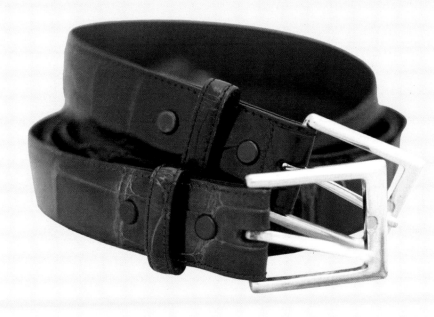

WHEN YOUR DISPOSABLE CASH IS SPILLING OUT OF
YOUR POCKETS, GO BACK AND SPLURGE ON THESE BLACK
AND BROWN AMERICAN-ALLIGATOR BEAUTIES.

SHIT

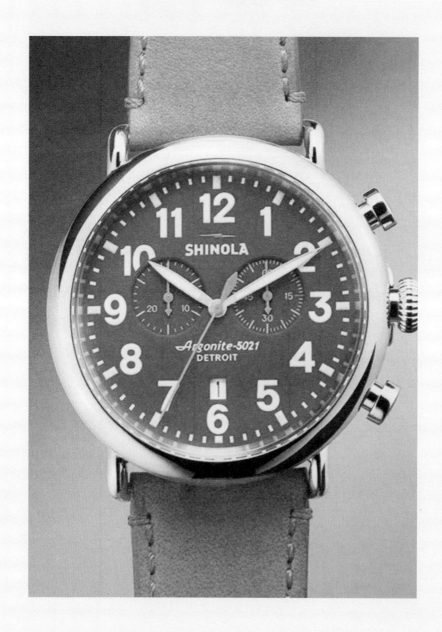

SHINOLA

MADE IN AMERICA IS A GREAT THING, BUT . . .

ZIPPO. YES.

FILSON. YES.

A SOUTHWICK SUIT. HELL, YES.

A SHINOLA TIMEPIECE. SHIT, NO!

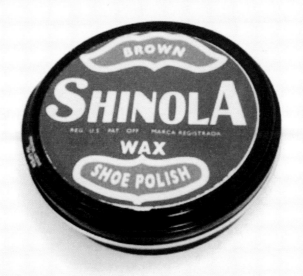

SHINOLA IS SHOE POLISH.

LEARN THE DIFFERENCE.

WRIST-WATCHES

DOS AND DON'TS

DO

INVEST IN ONE OR TWO CLASSIC WRISTWATCHES THAT YOU
CAN WEAR FOR THE REST OF YOUR LIFE AND THAT YOUR LOVED
ONES WILL FIGHT OVER WHEN YOU DIE.

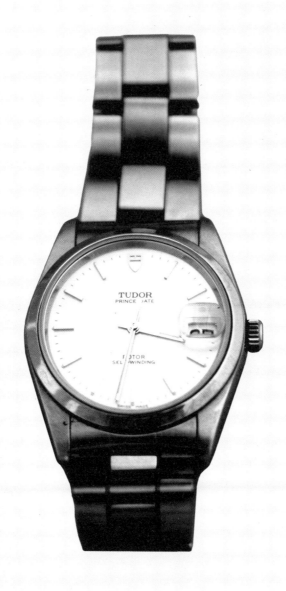

SAVE UP AND INVEST IN A TUDOR, OR, IF
YOU HAVE BEEN ABLE TO ACHIEVE ZERO DEBT
(WITH THE EXCEPTION OF A MORTGAGE), A ROLEX
(MINUS THE DIAMONDS, PLEASE). USE YOUR
PHONE TO KEEP TRACK OF THE TIME MEANWHILE.

DO NOT

GET SUCKERED INTO WASTING YOUR HARD-EARNED MONEY...

ON MULTIPLE OF-THE-MOMENT PIECES OF SHIT YOU SEE ADVERTISED
IN MAGAZINES—YOU KNOW, THE ONES THAT BASICALLY BECOME LANDFILL
THE MOMENT YOU WALK OUT OF THE STORE. SPEND THE MONEY ON A
PIECE OF ART. AT LEAST THERE IS THE REMOTE POSSIBILITY THAT IT
WILL INCREASE IN VALUE.

A MAN AND HIS JEWELRY

UNLESS YOU ARE AN EXCEPTION,
AND IT IS POSSIBLE THAT IN
FACT YOU ARE, BUT I REALLY
DOUBT IT, PLEASE PRACTICE
RESTRAINT WHEN IT COMES TO
ADORNING YOUR BODY WITH SILVER
AND GOLD AND PRECIOUS STONES.

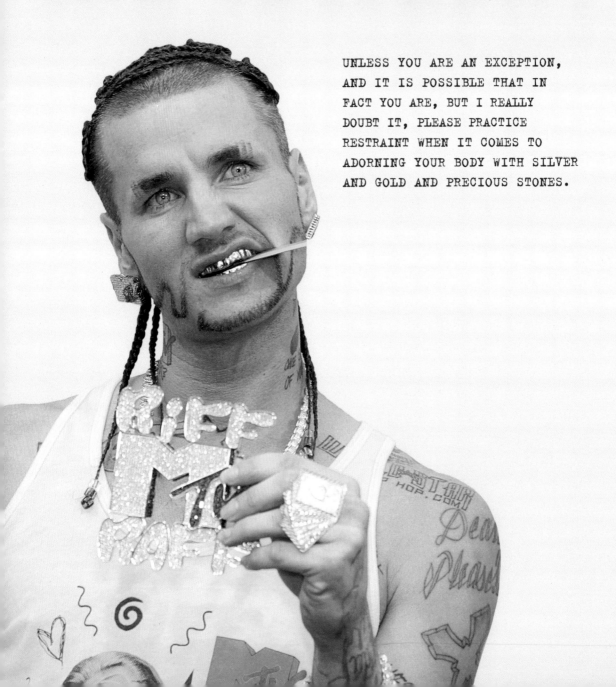

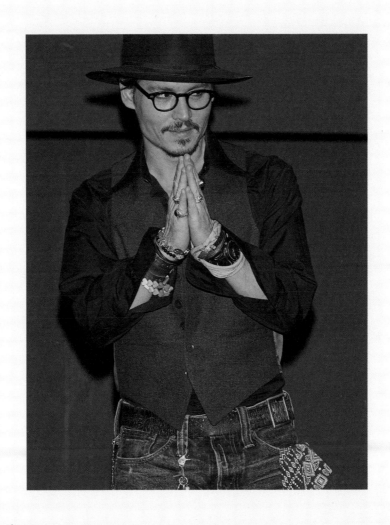

HOW LONG DOES IT TAKE JOHNNY DEPP TO GET DRESSED
IN THE MORNING—OR IS IT PROBABLY AFTERNOON BY THE
TIME HE GETS FINISHED? BUT IF YOU REALLY HAVE TO
SHOW THE REST OF US THAT YOU HAVE, IN FACT, RISEN
ABOVE, YOU GO GIRL.

NEW RULES

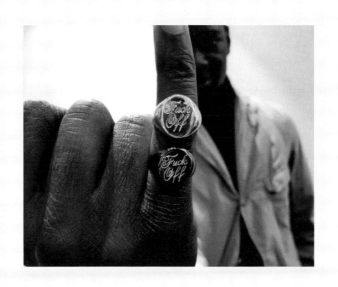

"FOXTROT UNIFORM CHARLIE KANYE" OFF.

DO NOT
BE AFRAID

TO BREAK THE
RULES . . .

BUT YOU'VE GOT TO KNOW THEM BEFORE YOU BREAK THEM.

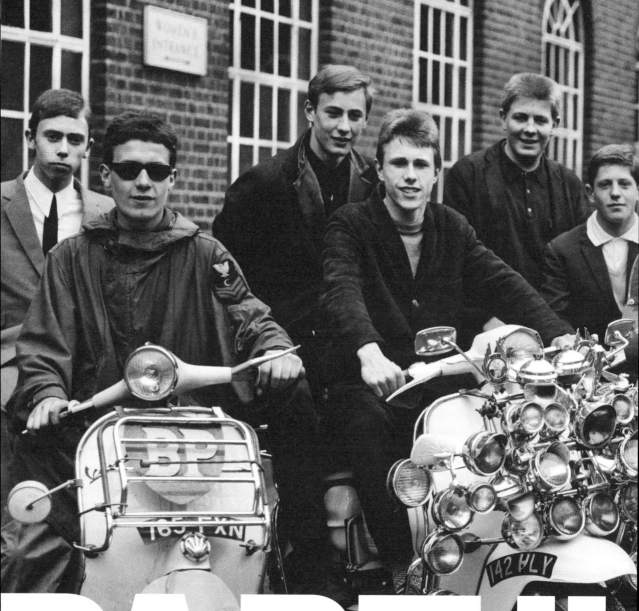

PART II

CLASSICS.

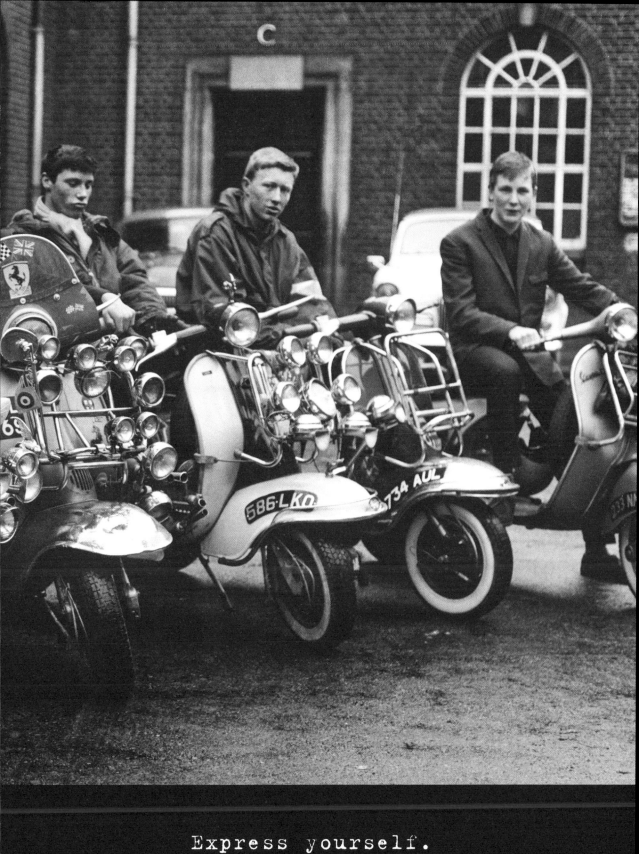

Express yourself.

WEAR ONLY ONE INTERESTING PIECE OF CLOTHING AT A TIME...

UNLESS YOU'RE NICK WOOSTER OR UNLESS YOU IS REALLY LIKE GOT IT GOIN' ON.

POINT IN CASE. I WAS ONCE REFUSED ENTRANCE TO THE RITZ HOTEL IN PARIS, WHEN I WAS GOING TO THE BAR FOR A DRINK WITH MICHAEL WILLIAMS. THE DOORMAN SAID HE DID NOT CARE FOR MY "COORDINATION." LUCKILY, BY CHANCE, JIM MOORE OF *GQ* HAPPENED TO BE EXITING THE BUILDING AT THAT VERY MOMENT. HE VOUCHED FOR ME, AND THEY LET ME IN. WHEN WE WALKED INTO THE BAR, REESE WITHERSPOON WAS THERE, AND MICHAEL SAID SHE WAS CHECKING ME OUT. LOOKING BACK, SHE WAS MOST LIKELY STARING AT ME BECAUSE I LOOKED LIKE A FUCKIN' FOOL. AND THE DOORMAN WAS ACTUALLY DOING ME A FAVOR, AND CORRECT IN HIS JUDGMENT. HE SHOULD NOT HAVE LET ME IN, AND IN FACT, I SHOULD HAVE GONE STRAIGHT BACK TO MY ROOM AND CHANGED. I AM NOT GOING TO SHARE THE PICTURE WITH YOU, BUT I AM PRETTY SURE, IF YOU SEARCH THE INTERNET, IT IS OUT THERE SOMEWHERE.

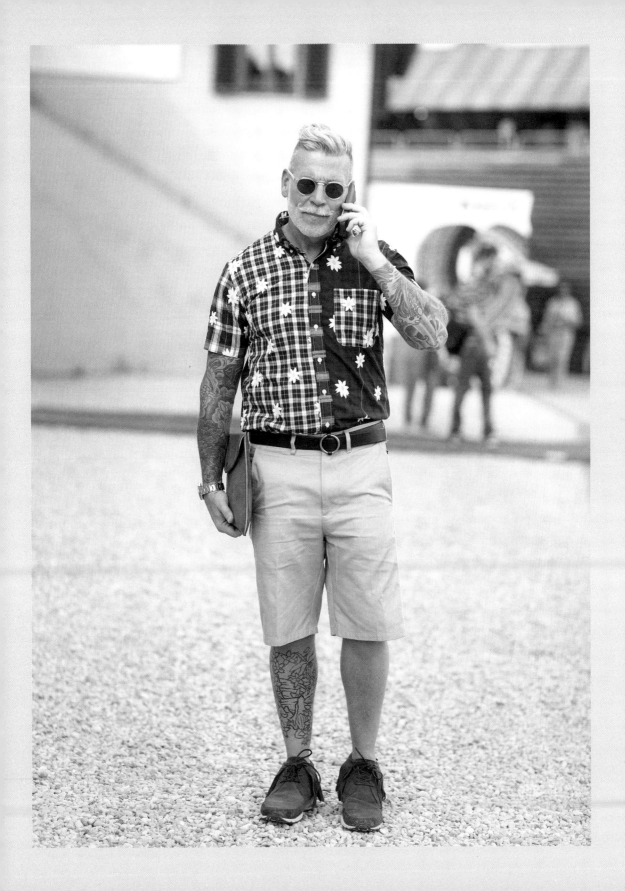

WARNING:
INTENDED FOR RUNWAY PURPOSES ONLY.

THIS LOOK IS MODELED BY A PROFESSIONAL.
PLEASE DO NOT ATTEMPT THIS AT HOME.

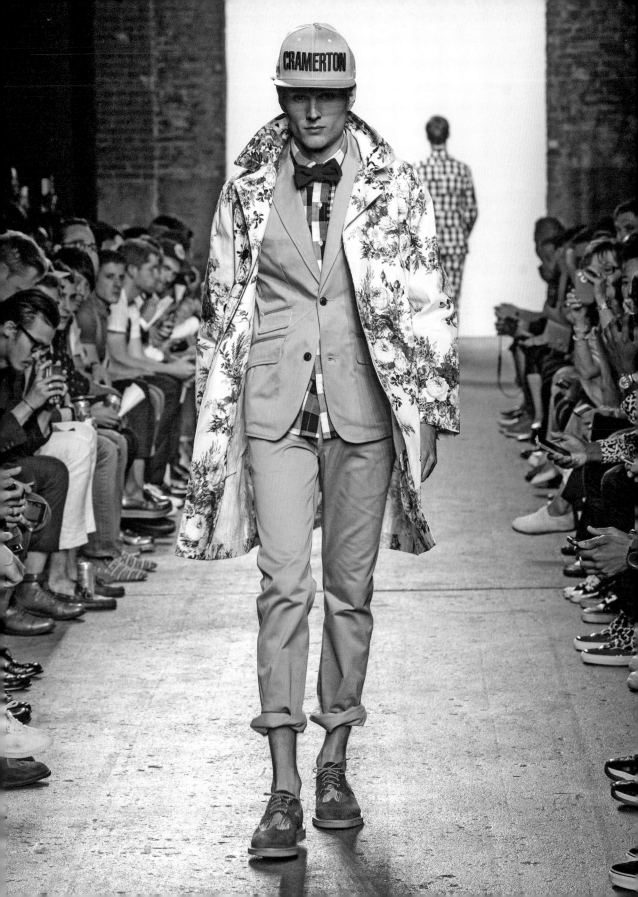

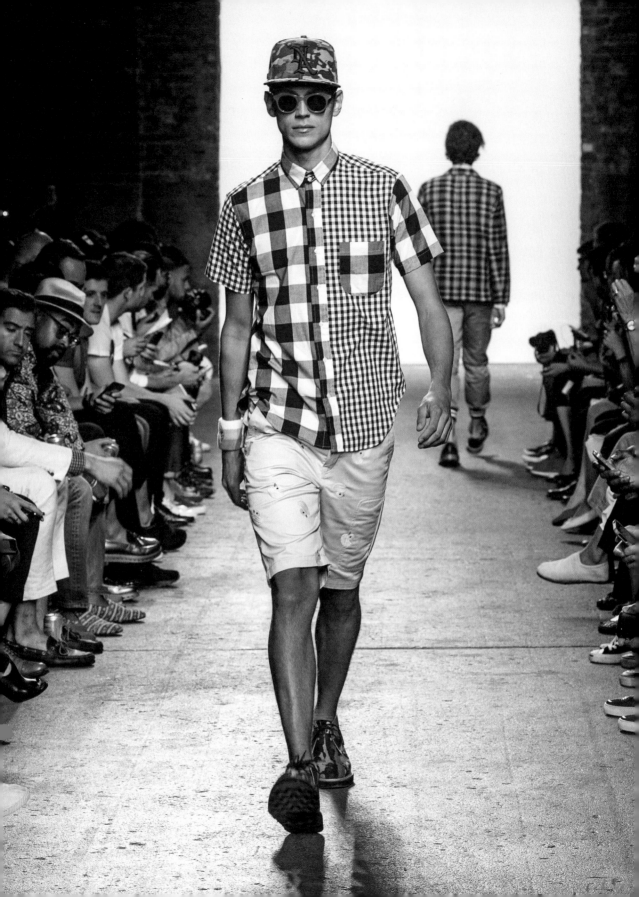

ALL WORK AND NO PLAY: THE FUN SHIRT

ORIGINALLY CREATED BY BROOKS BROTHERS, WHO COMBINED ODDS
AND ENDS OF LEFTOVER SHIRTINGS, THE SHIRT EVENTUALLY BECAME
STANDARDIZED, AND THEN I DONE UNSTANDARDIZED IT.

CAMOUFLAGE

MY INFATUATION BEGAN
WITH G.I. JOE.

THE WAY I SEE IT,
CAMOUFLAGE IS A
FLORAL PRINT FOR GUYS.

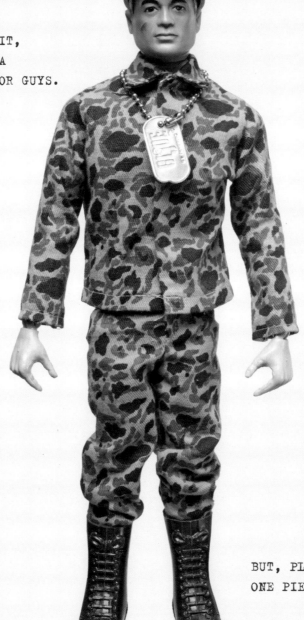

BUT, PLEASE: ONLY WEAR
ONE PIECE AT A TIME.

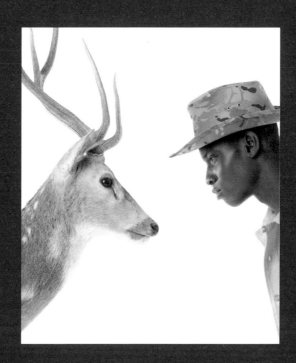

ODE TO MY HERO, BRIAN FELLOW

"THAT'S CRAZY!"

GINGHAM

SUITABLE FOR ALL OCCASIONS, FROM A PICNIC TO FINE
DINING IN THE CLAMPETTS' BILLIARD ROOM.

GINGHAM IS A GOOD WAY TO ADD A LITTLE FLAIR.

NAVY IS MY GO-TO.

GRAY IS ALSO NICE, AND KELLY GREEN IS COOL.

YELLOW GINGHAM IS A GOOD CHOICE WITH A GRAY SUIT.

I DO NOT THINK I COULD ROCK A RED GINGHAM SUIT, AND
I HIGHLY DOUBT YOU CAN EITHER. UNLESS YOU IS A CLOWN.

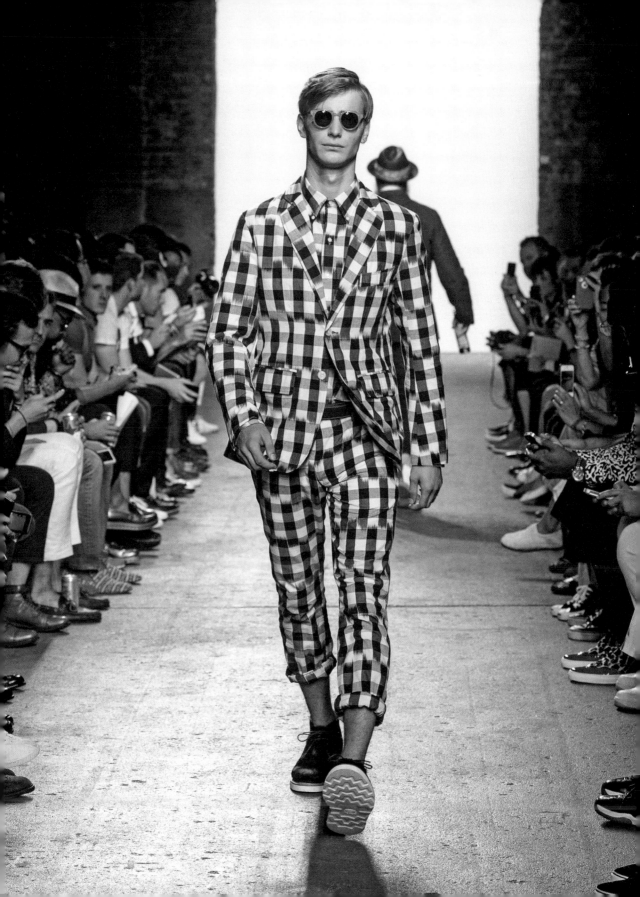

THE BIGGER THE DOTS,

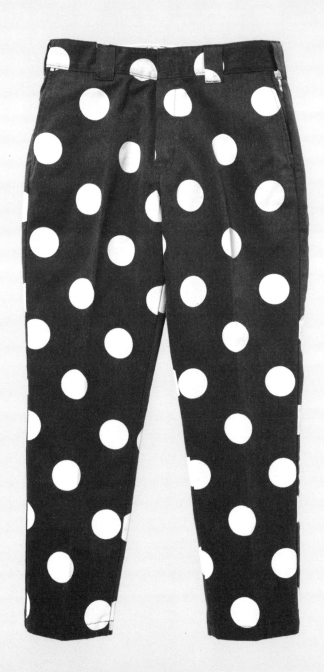

THE BIGGER THE BALLS.

MICRO DOTS ARE FOR GUYS WITH A MICRO SENSE OF ADVENTURE.

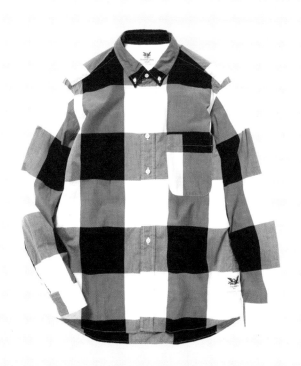

THIS ANALOGY ALSO APPLIES TO GINGHAM CHECKS.

THE POPLIN SUIT

A TAN POPLIN SUIT LOOKS SUPER COOL WITH A WHITE SHIRT, A
BLACK SILK KNIT TIE, AND A PAIR OF CHOCOLATE SUEDE DOUBLE
MONK-STRAP KICKS—NO SOCKS. TOP IT OFF WITH BORSALINO PANAMA
FEDORA AND A PAIR OF AVIATORS. SMOKIN'!

ESPADRILLES

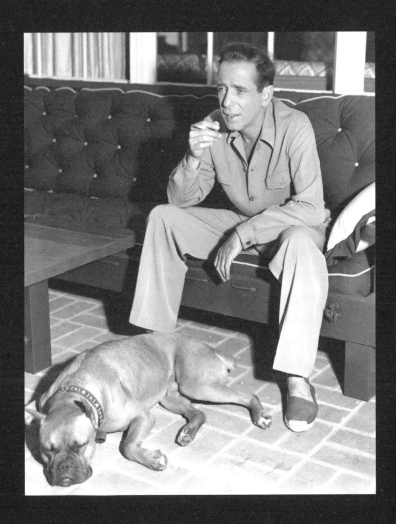

PERFECT FOR THE BEACH, OR PAIRED WITH A SPORTS JACKET FOR
FINE DINING. I SUGGEST WEARING YOUR ESPADRILLES WITH A
POPLIN SUIT WHETHER DINING AL FRESCO ON THE FRENCH RIVIERA
OR EN ROUTE TO KMART TO GET YOU SOME NEW UNDERWEAR.

LOOSE LIPS SINK SHIPS...

AND DILATED PUPILS CAN
BLOW YOUR COVER. KEEP
THEM EYES QUIET.

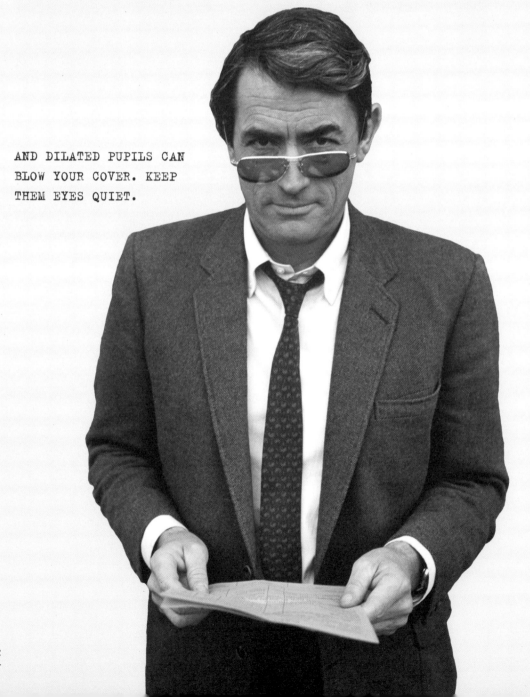

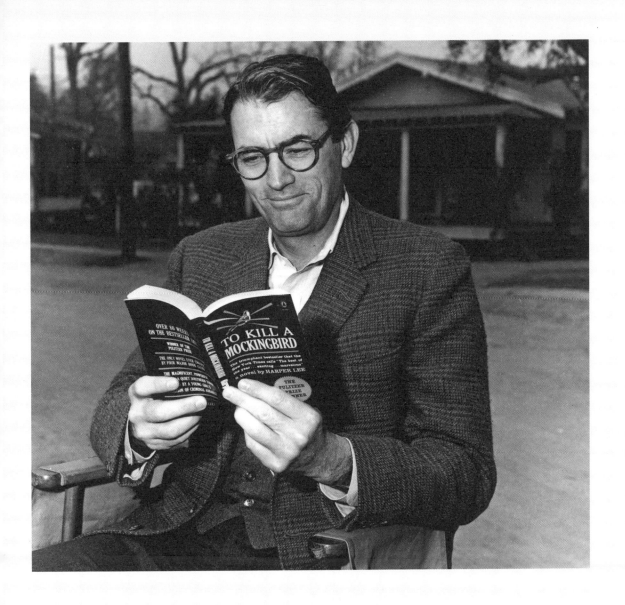

FRAMES

DO NOT MAKE A SPECTACLE OF YOURSELF.
BUY THE ONES THAT MAKE YOU SEE THE GOODEST.

HATS ARE NOT FOR EVERY GUY.

IF YOU ARE GONNA WEAR A HAT, WEAR IT. DO NOT JUST PUT IT ON.

PLEASE REMOVE YOUR HAT WHILE DINING, UNLESS YOU ARE DWIGHT YOAKAM. YOU, SIR, ARE AN EXCEPTION TO THIS RULE.

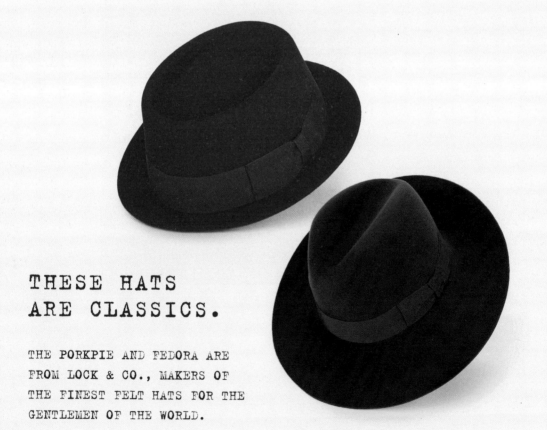

THESE HATS ARE CLASSICS.

THE PORKPIE AND FEDORA ARE FROM LOCK & CO., MAKERS OF THE FINEST FELT HATS FOR THE GENTLEMEN OF THE WORLD.

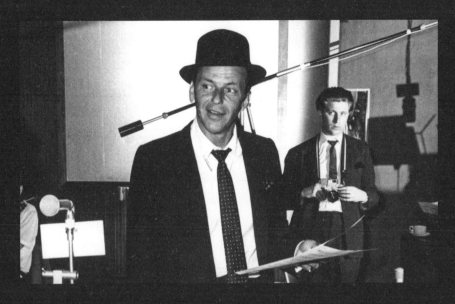

The Sinatra Porkpie
NAMED FOR THE MAN HIMSELF.

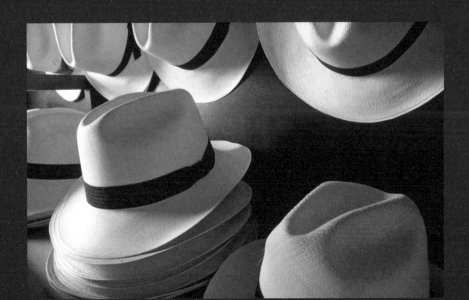

The Stetson Open Road

IT AIN'T A COWBOY HAT, ASSHOLE.

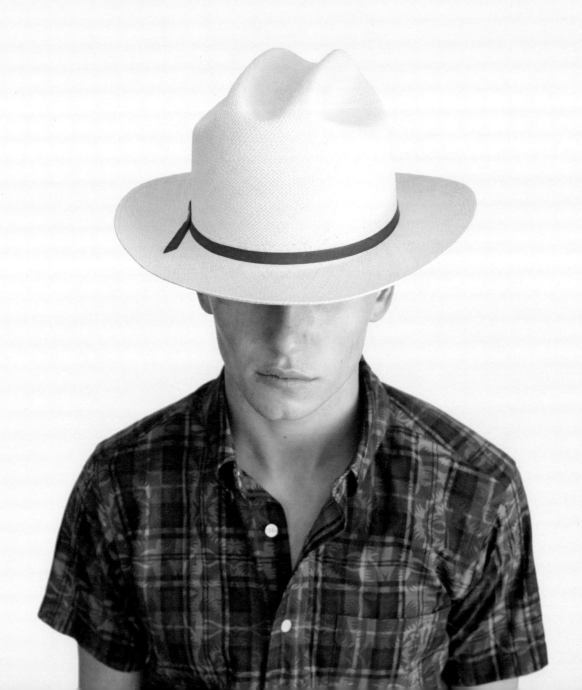

New Era Caps

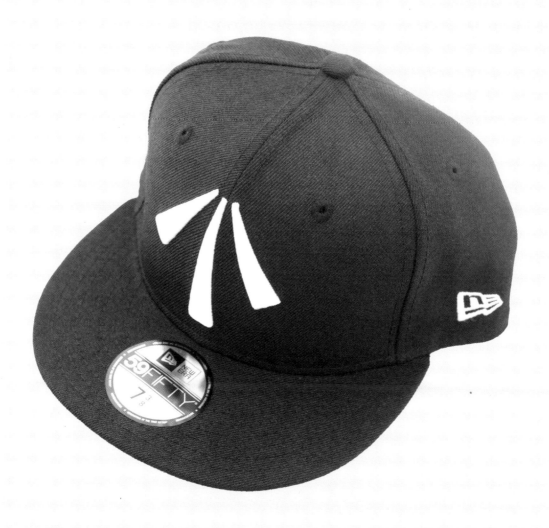

FOR PROFESSIONAL BALL PLAYERS AND
PROFESSIONAL BALLERS ALIKE.

WARM AS TOAST

THE MARTIN MARGIELA DRIVING SWEATER

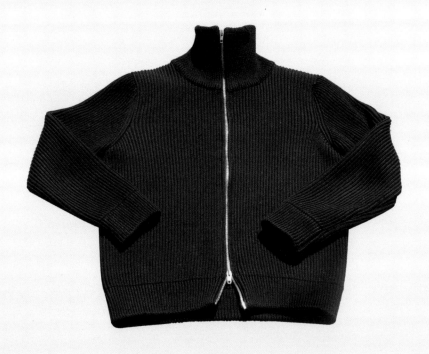

ONE OF THE THICKEST WEARABLES EVER CREATED.

IT IS AS THICK AS MY FUCKIN' SKULL.

BUT WHY NO POCKETS?

WHY IS THERE ONLY ONE COAT IN THIS BOOK?

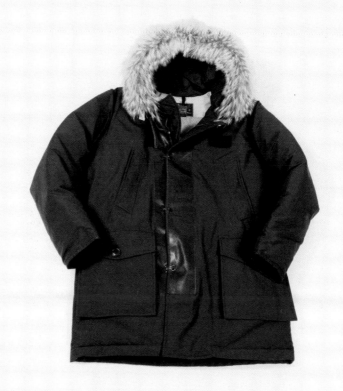

BECAUSE THE WOOLRICH ARCTIC PARKA IS THE ONLY COAT THAT MATTERS.

IT IS MORE THAN JUST A COAT. IT IS MY FRIEND—THROUGH THICK AND THIN.

ORIGINALLY CREATED IN 1972 FOR PIPELINE WORKERS IN ALASKA, THE PARKA IS A SYMBOL OF BOTH MY LOVE OF TRADITIONALISM AND BELIEF IN PERSONAL WARMTH. WHETHER YOU WEAR IT WITH NOTHING ON UNDERNEATH OR OVER A SUIT, THIS IS THE ONLY WINTER COAT YOU WILL EVER NEED.

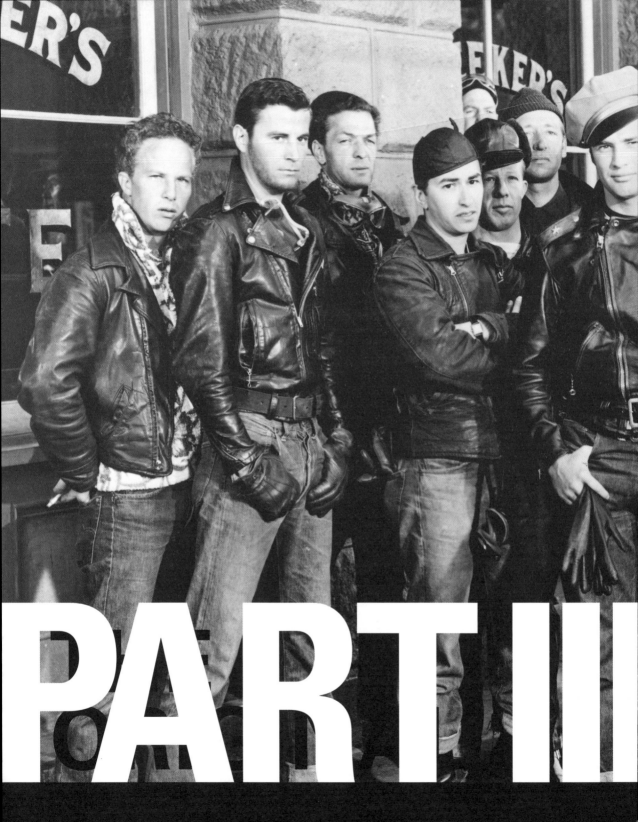

PART III

GOOD GUYS, GOOD ADVICES.

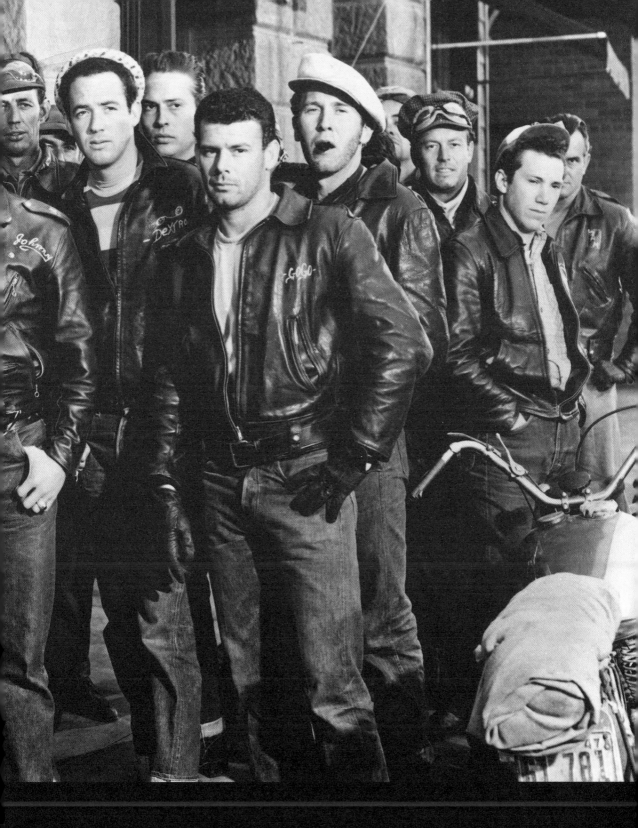

Look, listen, and learn.

"IT IS BETTER TO BE FEARED THAN LOVED, IF YOU CANNOT BE BOTH."

—NICCOLÒ MACHIAVELLI, *THE PRINCE*, 1532

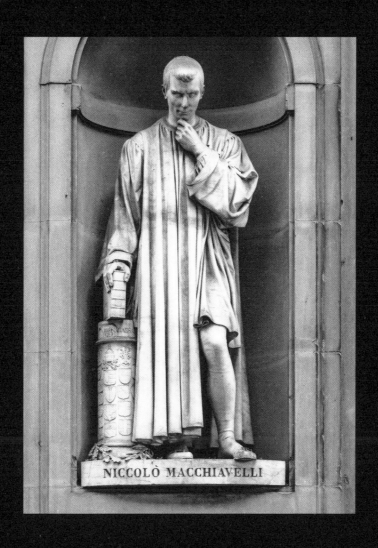

NICCOLÒ MACCHIAVELLI

(I SUPPOSE I SHOULD BE MORE FORGIVING WHEN
SOMEONE SPELLS MY FIRST NAME WITH A "C".)

SUCCESS

YOU ARE WELL ON YOUR WAY WHEN YOU ARE ABLE TO ASSEMBLE A
PIECE OF IKEA FURNITURE WITHOUT SAYING A CUSS WORD. YOU HAVE
ACTUALLY ACHIEVED SUCCESS WHEN YOU REACH THE POINT THAT YOU
NEVER HAVE TO PUT TOGETHER ANOTHER ONE OF THOSE GODDAMN
MOTHERFUCKIN' PIECES OF SHIT EVER AGAIN.

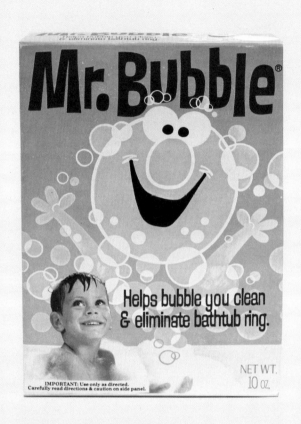

MAN THE FUCK UP,
AND INDULGE YOURSELF
IN A NICE BUBBLE BATH.

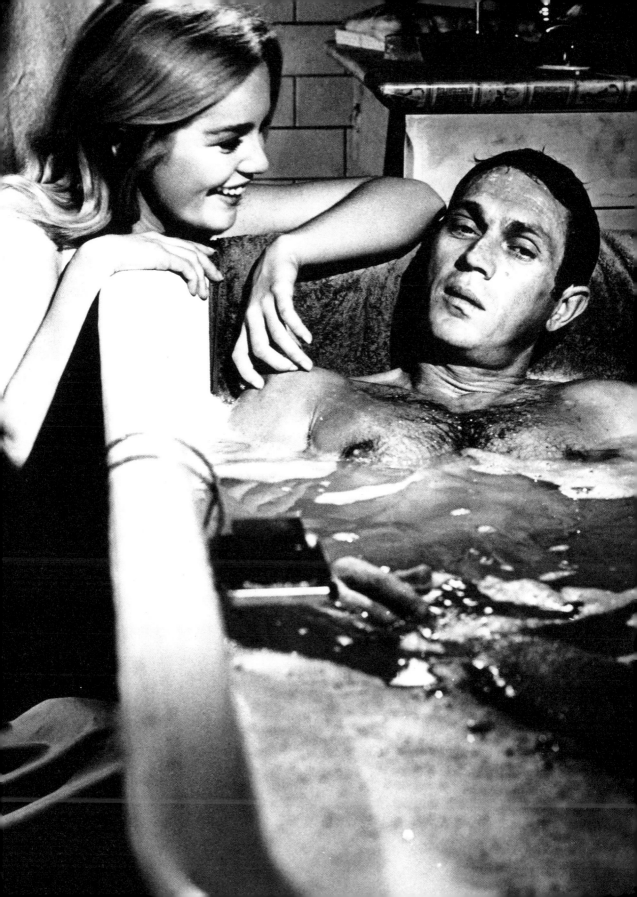

BE BORN LIKE REALLY, REALLY, REALLY, GOOD-LOOKING.

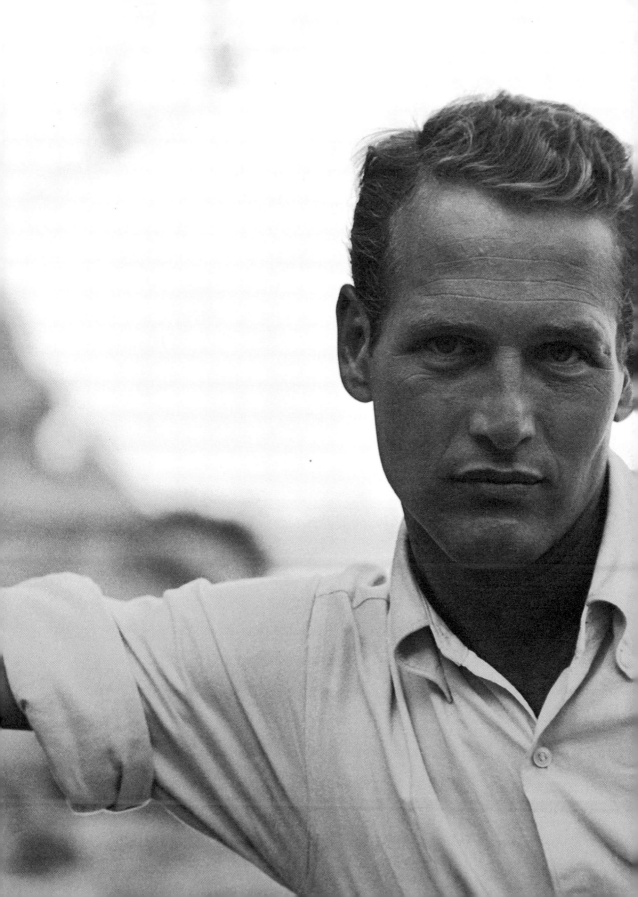

LEARNING A TRADE IS THE FIRST STEP TOWARDS FAILURE.

IT'S ON SALE FOR A REASON.

DON'T BUY SHIT JUST BECAUSE IT IS ON SALE, BECAUSE MOST
LIKELY WHEN YOU WEAR IT, YOU WILL LOOK LIKE YOU SHOULD BE
MARKED DOWN OR IN THE CLEARANCE SECTION.

A $1,225 SWEATER IS NOT AN INVESTMENT.

SO UNLESS YOU IS FO' REAL BALLIN',
YOU BETTER THINK TWICE.

ON LUXURY BRANDS

UNFORTUNATELY,
THIS CATEGORY NO LONGER EXISTS.

IF YOU ARE GOING TO TRY AND SET YOURSELF APART FROM THE
CROWD BY PURCHASING SOMETHING FROM THAT LOUIS VUITTON
GUY, YOU MAY AS WELL PURCHASE A LOBOTOMY.

ON
DESIGNER
BRANDS

DEFINITION: THE DESIGNERS ARE FINANCIAL
INSTITUTIONS AND CAN USUALLY BE FOUND IN
ABUNDANCE AT T.J. MAXX.

A WORD ON THAT OLD NAVY HOODIE.

DID YOU GRADUATE FROM OLD NAVY? AS FAR AS I AM CONCERNED, IT MIGHT AS WELL SAY, "I AM POOR BUT PROUD," OR PERHAPS MORE ACCURATELY, "I HAVE GIVEN UP."

AND IF YOU ARE OLD ENOUGH TO DRIVE WITH A LEARNER'S
PERMIT, YOU ARE TOO OLD TO WEAR ANYTHING FROM
ABERCROMBIE & FITCH.

SILENCE IS GOLDEN.

IT IS NOT WHAT YOU LIKE,

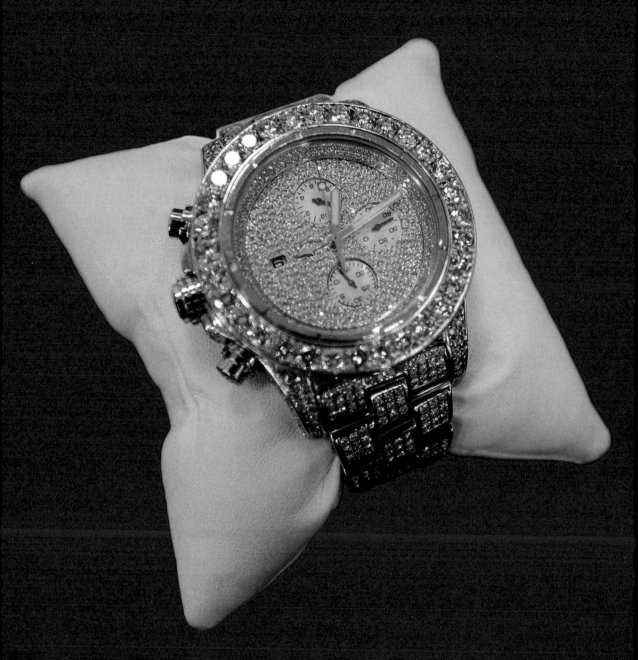

BUT HOW
YOU LIKE IT.

WATCH PBS FROM TIME TO TIME.

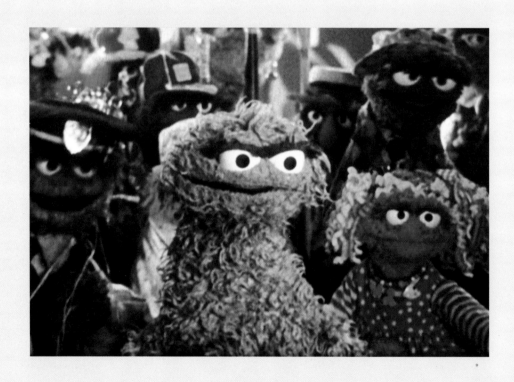

READ A BOOK

WHAT WOULD MACHIAVELLI DO?

STANLEY BING

Harper
Business

THE ROMPER ROOM DO BEE BOOK OF MANNERS

WONDER
BOOKS

763

HERE IS NEW YORK

E. B. WHITE

HARPER

the FOUNTAINHEAD

Ayn Rand

BOBBS
MERRILL

AND I DO NOT MEAN THIS ONE.

STICK WITH THE REAL DEAL.

YOU'VE FUCKED WITH THE BEST, NOW FUCK WITH THE BEST. I AM
SO SICK OF DOUCHE BAGS TELLING ME ABOUT THE "BEST" FRIED
CHICKEN AT SOME OBSCURE LOCATION IN BROOKLYN. I AM SURE
IT IS ORGANIC, COSTS ABOUT FIFTY DOLLARS, AND IS SERVED
UP BY SOME DUDE WITH AN AMAZING HAIRCUT, AN AWESOME BEARD,
SOME IRONIC T-SHIRT, A PAIR OF SKINNY-ASS JEANS THAT ARE
MOST CERTAINLY MADE IN THE UNITED STATES OF AMERICA, AND
A SET OF SOME OF THOSE "WHERE DID YOU GET THOSE AMAZING"
SECONDHAND RED WING BOOTS.

I'LL STICK WITH MY POPEYES, THANK YOU.

I LEARNED WAY MORE ABOUT HISTORY AND LIFE
FROM LISTENING TO ROCK 'N' ROLL THAN I
EVER LEARNED IN SCHOOL.

PROBABLY BECAUSE I WASN'T LISTENING.

Mose Allison

IF YOU DON'T KNOWS MOSE, I WOULD SUGGEST YOU GETS TO KNOW HIM.

R.E.M.

HOMEGROWN HEROES. FOUR GUYS START A BAND, MAKE IT UP AS THEY GO ALONG, AND BECOME ONE OF THE BEST AND MOST INFLUENTIAL BANDS IN THE WORLD. *CHRONIC TOWN* WAS RECORDED LIKE TWENTY MINUTES AWAY FROM WHERE I GREW UP. R.E.M. TAUGHT ME TO DREAM AND TO GET THE HELL OUTTA DODGE.

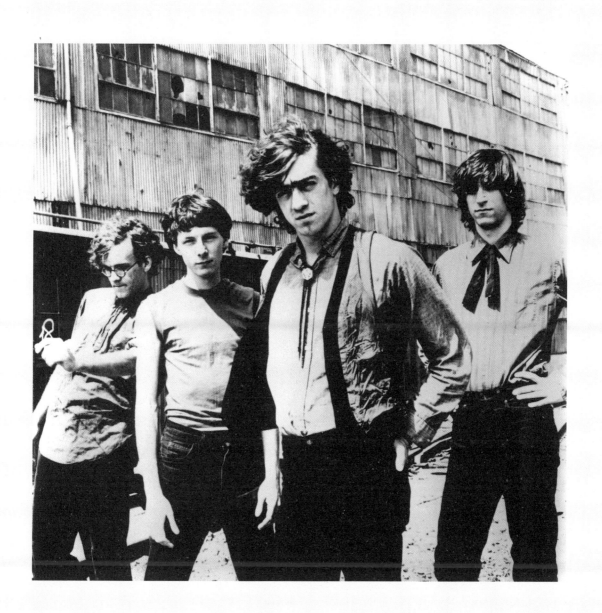

RALPH LAUREN

HE IS THE MAN WHO, BY STEPPING BACK TO MOVE FORWARD, CHANGED
EVERYTHING AND SET THE STANDARD FOR TAILORING. ALTHOUGH HE IS
A JEW AND I AM A GENITAL, WE SHARE A LOVE FOR *THE FOUNTAINHEAD*,
M&MS, AND AMERICA. FUCK YEAH.

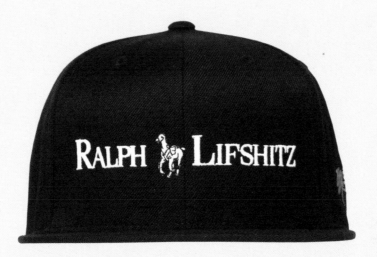

SHAWN STUSSY

THE BRAND, YOU KNOW. BUT LET US TALK ABOUT
SHAWN. RALPH LAUREN CHANGED THE GAME, BUT IN THE
WORLD WE LIVE IN TODAY, MR. STUSSY WAS EQUALLY,
IF NOT MORE, INFLUENTIAL.

SUPREME WOULD NOT EVEN EXIST IF IT WERE NOT FOR STUSSY.

STUSSY TRANSFORMED SURFWEAR,
INCORPORATING ELEMENTS HE ENCOUNTERED
IN TOKYO FROM COMME DES GARÇONS INTO
WHAT WE NOW CALL STREETWEAR.

SANDERS + SANDERS
AND MARK McNAIRY
AUG. 5. 2011

CAMEL "CHRISTY" VIBRAM SOLE

s/DOUBLE LONGWING BROGUE

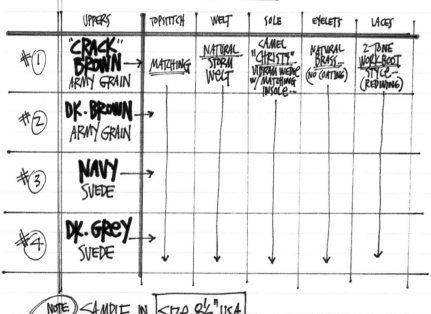

	UPPERS	TOPSTITCH	WELT	SOLE	EYELETS	LACES
#①	"CRACK" BROWN ARMY GRAIN →	MATCHING	NATURAL STORM WELT	CAMEL "CHRISTY" VIBRAM WEDGE w/ MATCHING INSOLE...	NATURAL BRASS... (NO COATING)	2-TONE WORK BOOT STYLE... (REDWING)
#②	DK. BROWN ARMY GRAIN →					
#③	NAVY SUEDE →					
#④	DK. GREY SUEDE →					

NOTE. SAMPLE IN SIZE 8½" USA

FUCK SUPREME.

But I love them both.

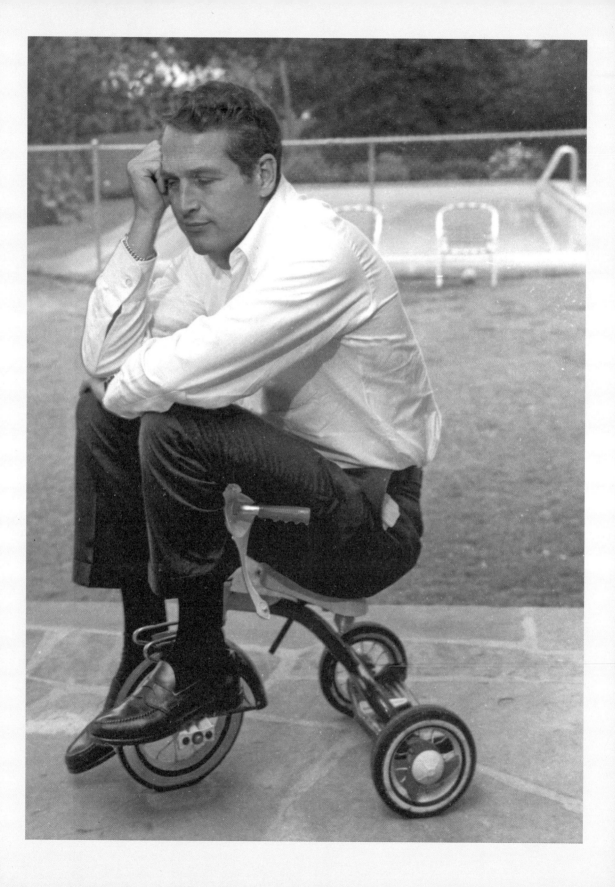

BUT SERIOUSLY, FOLKS.
DO NOT TAKE YOURSELF TOO SERIOUSLY.

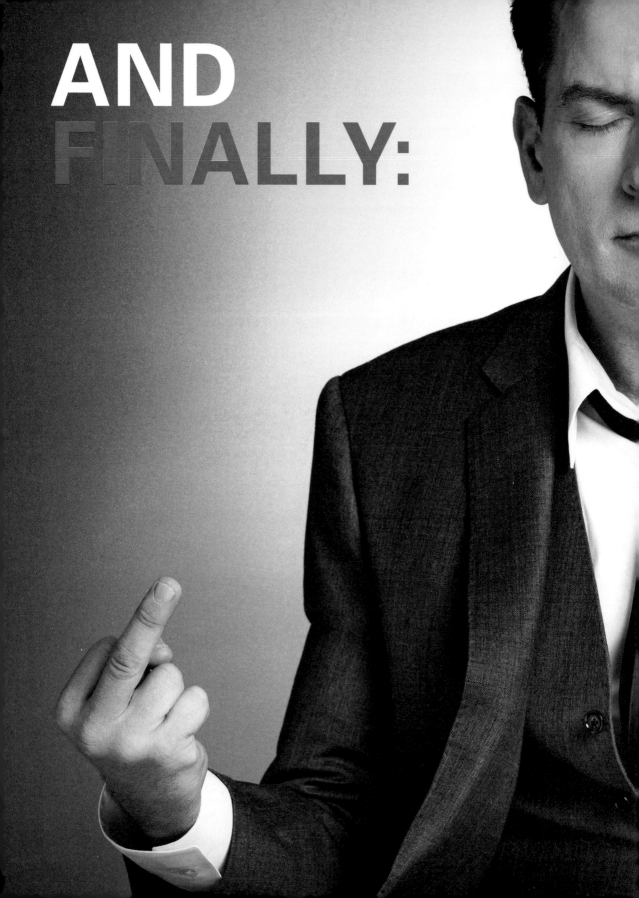

AND
FINALLY:

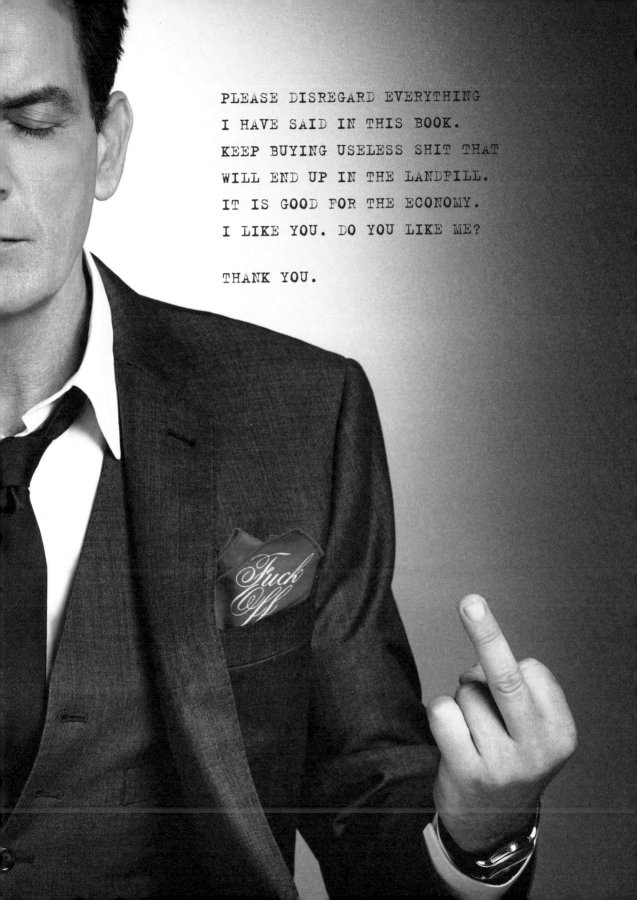

GLOSSARY

GOOGLE IT.

SELECT BIBLIOGRAPHY

MY HIPPOCAMPUS OR MY CEREBRAL CORTEX, DEPENDING ON YOUR
PARTICULAR VIEW OF SPATIAL ASSOCIATIONS.

ACKNOWLEDGMENTS

THANK YOU:

COOKIE, RY, DAY-Z, PAT AND HOLLY, MARY EDWARDS McNAIRY,
CRAIG, LISA ANN GORDON, JESS GRASSI, JIM SILVERMAN, E.C.,
MR. HENRY SANDERS, MICHAEL WILLIAMS, ANDY SPADE, NICK WOOSTER,
KUNI, PHARRELL, JEREMY DEAN, MR. GEORGE GRAHAM, LYNNE YEAMANS,
ELIZABETH VISCOTT SULLIVAN, PAUL KEPPLE, MAX VANDENBERG,
LEE CLOWER, JIM MOORE, BRUCE, WILLY DeVILLE, ANDY GRIFFITH,
DECLAN MacMANUS (FOR "NEW AMSTERDAM"), LEROY MERCER,
GRANT WILMOTH, GREG "SNOOP" CHAPMAN, LITTLE JIMMY OSMOND,
JETHRO, GUY #1, GUY #2, JACOBI PRESS, MARTIN SHEEN,
GREGORY WAYNE YATES, PETE MULLINS, CHIP BAKER,
MICHAEL GILES JACKSON, ROCKY RYAN, GORDON THOMPSON,
PERRY POOLE, BRADLEY HAROLD SMITH, LITTLE MATT, BIG MATT,
CARL GOLDBERG, AND KAZUKI KURAISHI—AND GOD BLESS THE
UNITED STATES OF AMERICA.

PHOTOGRAPHY CREDITS

ANGEL, JORGEN: 17 (Johnny Rotten, Daddy's Dance Hall, Copenhagen, 1977) © Jorgen Angel.

BOND, GAVIN: 170-171 (Charlie Sheen, w, 2012) © Gavin Bond.

CLOWER, LEE: 26-28, 31, 32, 42, 45, 50, 56, 59, 60, 70, 71, 73, 75, 79, 84, 92-95, 97, 115, 126-128, 141, 149, 155-156 © Lee Clower.

COLOMB, DENISE: 38 (Nicolas de Staël in his studio, Rue Gauguet, Paris, 1954) © Ministère de la Culture/Médiathèque du Patrimoine, Dist. RMN-Grand Palais/Art Resource, New York.

CORBIS: 66 © Image Source/Corbis; 69 © Roy McMahon/Corbis; 100 (Riff Raff at the 2012 MTV Video Music Awards), Jennifer Graylock/INFphoto.com/Corbis; 106-107 (Mods with their bikes, 1964) © Daily Mirror/Mirrorpix/Corbis; 125 © Owen Franken/Corbis; 130-131 (motorcycle gang in The Wild One) © John Springer Collection/Corbis.

DAVIS, AMY: 87, Amy Davis/Baltimore Sun staff photographer, 2014. © The Baltimore Sun. Reprinted with permission of The Baltimore Sun Media Group. All Rights Reserved.

GETTY IMAGES: 14-15, Ed Marker, The Denver Post via Getty Images, 1966; 21, A.Y. Owen, 1957. The LIFE Images Collection/Getty Images; 22, Ted Spiegel for National Geographic/Getty Images, 1963; 33 (Jackson Pollock, 1949), Martha Holmes, The LIFE Picture Collection/Getty Images; 58 (Paul Newman, circa 1960), CSFF/RDA/Getty Images; 76 (Gerry Mulligan, circa 1950), Bob Willoughby, Willoughby/Redferns/Getty Images; 89, Miquel Benitez/Getty Images; 101 (Johnny Depp at a Sweeney Todd press conference, Tokyo, 2008), JIL Studio/WireImage; 120 (LIFE magazine cover, March 20, 1964), Larry Burrows, the LIFE Premium Collection/Getty Images; 122 (Gregory Peck during the filming of Arabesque, London, 1966), Hulton Archive/Getty Images; 135, Richard Ellis/Getty Images; 143, Mark Klotz; 144-145 (lobotomy procedure, 1946), Kurt Hutton/Picture Post/Hulton Archive/Getty Images; 146-147, Daniel Acker/Bloomberg via Getty Images; 153, Gabriel Bouys/AFP/Getty Images; 159, Keystone-France/Gamma-Rapho via Getty Images; 160 (Mose Allison, circa 1970), Michael Ochs Archives/Getty Images; 168 (Paul Newman, 1962), New York Daily News Archive via Getty Images.

GRAV, HÅKON: 86 (Twisted Sister, 2005) © Håkon Grav.

HYPEBEAST: 13 (Mark McNairy for Heather Grey Wall, Inferior Collection, 2012), photograph of Arthur Bray, DJ at Yeti Out and editor of HYPEBEAST, courtesy of HYPEBEAST.

JENG, MELODIE: 109 (Nick Wooster, 2014) © Melodie Jeng.

KARABLIN, RUSSELL: 163 (Ralph Lifshitz Hat, SSUR) © Russell V. Karablin.

KEYSTONE PICTURES USA/ZUMAPRESS/NEWSCOM: 91 (John F. Kennedy, Jr., Athens, Greece, 1975).

KURAISHI, KAZUKI: 118, 119 © Kazuki Kuraishi.

LEVI'S VINTAGE CLASSIC: 24-25 (Historic 1955 501 Jeans in Rigid), © Levi's Vintage Clothing, 2015; 30 (1920s 201 Jeans in Rigid), © Levi's Vintage Clothing, 2015.

LOCK & CO. HATTERS: 124 (Louisiana fedora and Sinatra porkpie hats) © Lock & Co. Hatters.

LYON, DANNY: 18-19 (Chicago, 1965) © Danny Lyon/Magnum Photos.

McNAIRY, MARK: 98, 163: Courtesy of Mark McNairy.

McNAIRY, PAT AND HOLLY: 10 (Mark and Lisa McNairy, circa 1968): Courtesy of Pat and Holly McNairy.

MPTV IMAGES: 121 (Humphrey Bogart at home with his pet boxer, circa 1949), photographer unknown; 138-139 (Paul Newman on location in Israel during the filming of Exodus, 1960) © Leo Fuchs, 1978.

MUIR, RYAN: 111, 112, 117 © Ryan Muir.

NEPENTHES NEW YORK: 103 © Nepenthes NY, 2011.

O'NEILL, TERRY: 67 (Elton John, 1975) © Iconic Images/Terry O'Neill.

PHOTOFEST: 35 (James Dean in Giant, 1956) © Warner Bros. Pictures; 36 (Ronald Reagan in Hellcats of the Navy, 1957) © Columbia Pictures; 37 (Peter Sellers in The Party, 1968) © United Artists; 47 (Snoopy Comes Home, 1972) © National General Pictures; 52 (Frank Sinatra, Dean Martin, and Peter Lawford in Ocean's Eleven, 1960) © Warner Bros. Pictures; 55 (Jonathan Winters in Mork & Mindy, ABC, Season 4, 1981-82) © ABC; 57 (Against the House, 1955) © Columbia Pictures; 61 (Cary Grant in North by Northwest, 1959) © MGM; 62 (Lunch with Soupy Sales, ABC, 1963) © ABC; 65 (Humphrey Bogart with Audrey Hepburn on the set of Sabrina, 1954) © Paramount Pictures; 80 (Steve McQueen in Bullitt, 1968) © Warner Bros. Pictures; 82-83 (Bryan Cranston in Breaking Bad, AMC, 2008) © AMC; 123 (Gregory Peck reading To Kill a Mockingbird on set during the making of the film, 1962) © Universal Pictures; 125 (Frank Sinatra in a London recording studio, 1962) © MGM; 137 (Steve McQueen with Tuesday Weld in The Cincinnati Kid) © MGM; 142 (Reno 911!: Miami, 2007), photograph by Glenn Watson) © 20th Century Fox; 154 (Oscar the Grouch and other grouches. The Adventures of Elmo in Grouchland, 1999) © Jim Henson Productions/Columbia Pictures; 161 (R.E.M., early 1980s).

STÜSSY, SHAWN: 165: Courtesy of Shawn Stüssy.

SHUTTERSTOCK: 48 © Gualtiero Boffi; 49 © Montego; 104-105 © Everett Collection; 133 © Nickolay Stanev.

VICTORIA AND ALBERT MUSEUM: 114 (G.I. Joe Action Marine, Hasbro, 1964-1965) © Victoria and Albert Museum, London.

THE VILLAGE COMPANY: 136 (Mr. Bubble Box): © The Village Company.

WILEY, MARCUS: 90: © Marcus T. Wiley, 2015.

WILMOTH, GRANT: 176: Courtesy of Grant E. Wilmoth.

WP LAVORI IN CORSO: 129 (Woolrich Woolen Mills arctic parka) © WP Lavori in Corso SRL, 2011.

YULSMAN, JERRY: 41 (Jack Kerouac, Greenwich Village, New York, late 1950s), Globe Photos, Inc.

First published in 2016 by
Harper Design
An Imprint of HarperCollins*Publishers*
195 Broadway
New York, NY 10007
Tel: (212) 207-7000
Fax: (855) 746-6023
www.hc.com
harperdesign@harpercollins.com

Distributed throughout the world by
HarperCollins*Publishers*
195 Broadway
New York, NY 10007

ISBN 978-0-06-237740-1
Library of Congress Control Number: 2014944762

Book design by: Headcase Design

Printed in Thailand
First Printing, 2016

ABOUT THE AUTHOR

Mark McNairy is not an accredited designer, nor does he hold an advanced degree in any of the social sciences. He is simply an enthusiastic young man with an abiding love for all of God's creatures. Somehow he has managed to become a globally recognized menswear designer. He is the creative vision behind Mark McNairy New Amsterdam, the creative director for Woolrich Woolen Mills, and the creative director of the Bee Line and BBC Black, both collaborations with Pharrell Williams and Billionaire Boys Club. He has collaborated with brands such as Keds, Timberland, Bass, Adidas, Heineken, and Zippo. The former creative director of J. Press, Mark has been named a Woolmark Prize Finalist, *GQ*'s Best New Menswear Designer in America, and *Complex*'s Man of the Year in Style. A member of the CFDA, he lives in Los Angeles.

Shop.Markmcnairy.com.